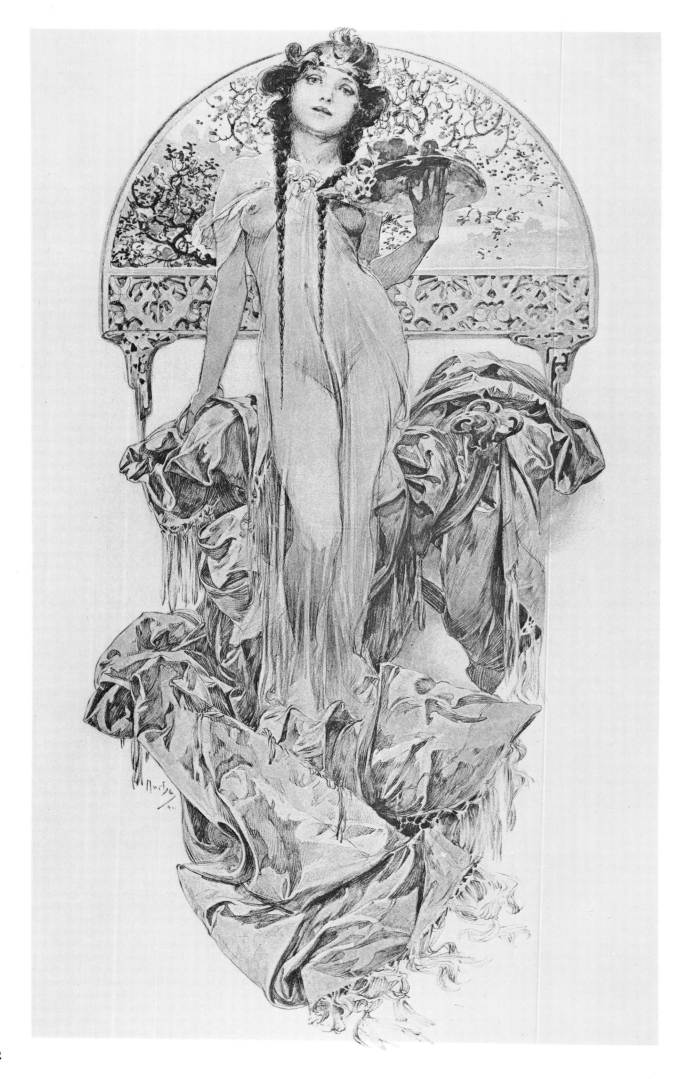

PLATE 2

# The Art Nouveau Style Book of

# ALPHONSE MUCHA

## All 72 Plates from "Documents Décoratifs" in Original Color

Edited by
### David M. H. Kern

Dover Publications, Inc.
New York

# Publisher's Note

The Moravian artist Mucha (1860–1939), trained in Vienna and Munich and active in Paris at the turn of the century, is the best-known practitioner of the Art Nouveau style in the graphic arts. His fame began with a poster for Sarah Bernhardt in December 1894, and for the next ten years he was constantly busy with commissions for posters, menus, programs and book illustrations. He also created numerous *panneaux décoratifs*, "ornamental panels" that were actually lithographs printed on heavy paper or silk and used as hangings or screens.

Although all of Mucha's work was widely imitated and was a great source of inspiration for other artists and craftsmen, Mucha produced two portfolios specifically as treasuries of ideas. The later one, the *Figures décoratives* of 1905, is very fine, but exclusively devoted to the human figure (women and children). Of much wider application is the 1901 portfolio *Documents décoratifs*, the very title page of which promises "ornamental panels, natural and decorative studies of flowers, wallpaper, friezes, stained glass, jewelry, etc." The "etc." includes designs for furniture, ceramics and needlework; figure studies; graphic ornaments, borders and lettering; and much more. Truly, as the art historian Marina Henderson has written, the 72 lithographic plates of *Documents décoratifs* comprise "an encyclopedic source for Mucha's style in every branch of decorative and applied art." By extension, the portfolio can safely be called one of the outstanding monuments of the Art Nouveau style in general.

The present edition retains the full color of the 18 plates that were originally so printed. For the other 54 plates, in which various additional tints were used, this volume features red, green, blue and brown tones that simulate those of the original publication (with some unavoidable variations).

Published in Canada by General Publishing Company, Ltd., 30 Lesmill Road, Don Mills, Toronto, Ontario.
Published in the United Kingdom by Constable and Company, Ltd.

*The Art Nouveau Style Book of Alphonse Mucha*, first published in 1980, is an unabridged republication of the 1901 portfolio bearing the title-page copy: *Documents décoratifs par A. M. Mucha / Panneaux décoratifs. — Études et applications de fleurs. — Papiers peints. — Frises. — Vitraux. — Orfèvrerie, etc., etc. / 72 planches / Préface de Gabriel Mourey / Paris / Librairie Centrale des Beaux-Arts / Émile Lévy, Éditeur / 13, rue Lafayette, 13.*
Exigencies of production have necessitated a new sequence of the plates and some variations in the additional tints of certain plates. Concordances between original and new plate numbers have been provided.
The Publisher's Note and the translation of the Foreword by Gabriel Mourey were prepared specially for the present edition by Stanley Appelbaum.

Editor and publisher are grateful to Edward and Judy Field of Pacific Palisades, California, for making their rare complete portfolio available for reproduction.

*International Standard Book Number: 0-486-24044-4*
*Library of Congress Catalog Card Number: 80-66136*

Manufactured in the United States of America
Dover Publications, Inc.
31 East 2nd Street
Mineola, N.Y. 11501

# FOREWORD
## by Gabriel Mourey

N art composed of charm and grace, delicacy and love . . . Mucha's art is as entrancing as those Asiatic chants whose rhythm, very simple and at the same time very complex, caresses and intoxicates those who listen. The music is ardent, highly colored, subtle and feverish, and they would gladly die while in the thrall of such harmonies.

Even after the instruments and voices have fallen still, an obsession with them persists; our memory exhausts itself in attempting to join together once more the broken threads of the melodic embroidery. The marvelous shawl, woven of moonbeams and petals, becomes frayed in the wind of reality; and of the exciting pleasure, the ineffable anguish, the fantastic dreams into which that music carried you, there remains only a "fragrant memory."

The analogy between that art and Mucha's is even more real and profound. The poet-musician and the designer drink at the same fountains of inspiration and the secret of their charm is the same. Flowers, women, celestial bodies: these are their favorite motifs. Their universe is a garden inhabited by beautiful women of languorous grace, with unspoiled nature in their glances; a garden in which the shrubbery sparkles with stars and flowers, in which cascades of precious stones flow by, in which clouds of artificial perfumes create a deliciously enervating atmosphere and strange fairy palaces suddenly shoot up, their splendor doubled by their reflection in the lakes. Is it the Garden of Eden . . . or Mohammed's paradise? Is it the Venusberg or Valhalla? But what does that matter? Let us open our portals wide to admit anyone who possesses the gift of moving us and charming us; let that man always be made welcome who is able to produce the mirage of a lovely dream in the midst of the sorrows and platitudes of our existence.

Even if Mucha's success were not justified by his talent and based on a body of work of recognized value (it should not be forgotten that he was one of the best pupils of Jean-Paul Laurens), it could thus be explained by the power to charm and the exotic flavor that are so peculiarly his. All question of art set aside, the enthusiasm with which he is greeted is easily understood. For he brought us a new vision of things, his own, fresh, vibrant with sunlight, passionate and at the same time a little naïve, flowery, astral, sumptuous and also barbarous, with reminiscences of Oriental pomp, with echoes of Byzantine splendors, and with a hieratic style combined with Parisian affectations—typical of a foreigner newly arrived in Paris from his far-off native land—with a sort of erotic mysticism, a special cult of female beauty: all of this condensed and amalgamated in a personal manner, with a skill that is not annoyingly conspicuous and a precision in his fantasy that sets down every detail scrupulously but nevertheless adorns the finished work with the vague outlines of an apparition. It is easy to understand the fascination that this art exerted on an artist like Sarah Bernhardt, for whom Mucha was later to design sets, and it is also easy to understand its widespread influence. Triumph was immediate. On the same day that the poster for *Gismonda* appeared on Parisian walls, Mucha was famous. The success that so many others await for long periods came to him all at once and has remained faithful to him, as it does to all those who possess true originality. There are originalities that remain mysterious or that reveal themselves, when they do so, slowly and only to the initiated; these are the strongest and most profound originalities and also those which can most victoriously brave the future. Others, easily penetrated, manifest themselves at once and all the more glaringly because they correspond more readily to certain trends, needs or appetites of public taste. Mucha doubtless profited from the same reawakening of idealism that was to assure the triumph of Edmond Rostand's verse plays. He arrived at the right time; five or ten years earlier, he might have been received very differently despite his rare gifts and the solidity of his talent. At that moment, in novels, plays and works of art, people were tired of the excessive violence with which some creative artists were depicting reality; in both painting and play writing, the "slice of life," as the phrase went in that already faraway period, no longer satisfied; a reaction was imminent. The older pessimism gave way to gracious optimism; the indulgent philosophy of wreaths of smiles replaced the nastiness of the preceding fad. The manufacturers of fairy tales for grown-ups, realizing that after all it would be impossible to adorn the contemporary scene with sufficient frills, escaped into the past and returned from Greece or Byzantium, China or

Italy, the Middle Ages and the Renaissance, with their portfolios full of beautiful tales of love or adventure.

The precious qualities of Mucha's talent were of the precise kind to suit the spirit of such a movement; when thus placed side by side with analogous efforts, his works take on a wider significance. They prove to be expressive of the preoccupations, the viewpoint and the taste which those who will one day write the history of public taste at the end of the nineteenth century will not be able to overlook. Morose or malevolent critics were annoyed by the vogue his works enjoyed, but they failed to recognize his merits and to associate him with the movement in which he participates. If the masses so spontaneously favored him, applauded his vision and made it their own, this proves their real progress in understanding art and the excellence of their judgment. Posters like those for *Gismonda, Amants,* the *Revue pour les jeunes filles, La dame aux camélias, Lorenzaccio,* Job cigarette paper and Champagne biscuits, to name only the major ones, are finished examples of Mucha's artistic goals and the undeniable mastery he has achieved. He will remain known as the initiator of this composite style, somewhat Byzantine and combining classical memories with a very contemporary languor. It is only doing him justice to state that he has always been sincere and spontaneous, even in his complexities, even in his boldest subtleties.

Moreover, the very success that met his first efforts soon made it possible for him to show how capable he was in branches of art other than those within which chance confined him at first. Had he not really started out as an illustrator? Had he not indeed remained a pure illustrator in his posters? Without blaming him for it, do not his posters look like illustrations when they are reduced? They fit wonderfully into a framework of letterpress; totally unlike Chéret's, their principal charm lies in their lines rather than in their masses of color. In addition, is not Mucha always more concerned with linear composition than with color composition, and are not his best works those in which color plays only a secondary role and appears merely as a highlight or in lightly applied flat tints? See, for example, his illustrations for Robert de Flers's *Ilsée, princesse de Tripoli.* There more than anywhere else Mucha is himself, master of his talent, channeling the spurts of his imagination into the rhythm of a tale; his special ability to suggest more than is seen is unfurled in images of the most striking charm; and what pleasing grace in those text borders which treat flowers so personally, so delicately, with so much love and poetry!

Quite different, in both inventive character and technique, are the 15 compositions executed by Mucha for the *Scenes and Episodes of German History.* Here the ornamentalist steps aside and the dramatist appears— powerful, to be sure, but in our eyes the power is external; the indispensable violence of gesture, ardor of heroism and striving for exactness seem to suit the artist's temperament less than perfectly. This work savors of the academy; it recalls the large historical paintings executed yearly by the official painters of all countries that possess a history and official painters. The personality of the artist, strained by a task for which his natural inclinations do not fit him, is practically invisible, and to find anyone else's signature on this work would be only mildly surprising. Mucha's assets and faults are both absent; the assets and faults that do appear are foreign to him.

This is because in truth Mucha is a decorative artist first and foremost. From the truth he observes, he is able to separate out the essential features and from them form a new, personal synthesis appropriate to the special purpose of the occasion; from patiently and methodically studied nature he is able to extract the elements of beauty and harmony which he will use to adorn, enrich, illuminate and perfect his decorative dream. He knows the laws that govern the structure of objects and it is from these changeless laws that he has attempted to deduce the precepts of harmony, balance and logic in accordance with which he works. Therefore, even in his most complex and intertwined compositions he always remains clear and precise, featuring the important details with surprising perspicacity and tact, giving each element its proper place, the only one it ought to occupy in the ensemble. Study carefully his book and magazine covers, his decorations for book pages, his posters, and you will be surprised, as you examine the relations among the various ornamental or floral elements of which the entire structure is composed, to see what logic, what sense of balance are inherent in their arrangement. No line or mass is present that is not compensated by a line or mass of proportionate strength; all the elements combine, balance one another, support one another and justify their existence. After such an analysis, the viewer is left marveling at the originality of invention, the spontaneous energy that have joined up as if subconsciously with so much precision and knowledge to produce the parts and the whole; for that sort of charm, that irresistible attractiveness of which I was speaking just before, could never be the result of merely dry professional knowhow. Through conscientious study, through patient observation, the artist's eye has succeeded in recording the eternal proportions and harmonies of nature, and his hand, by a sort of acquired instinct, if that term is permissible, has become accustomed to reproducing them; they recur quite naturally at the tip of his pencil or brush, which has only to transcribe them docilely.

Mucha would remain a decorative artist in spite of himself should he ever wish to resist his natural impulses. Do you remember the jewelry he exhibited at the World's Fair [Paris, 1900]? Brooches and diadems, gorgets and pendants of Oriental splendor, as if intended for the triumph of a Sheherazade or a Theodora, strange and sumptuous jewels in the composition of which the designer gave free rein to his fancy and which I am sure will remain those of his works in which he has expressed himself most completely, in the free exercise of his imaginative powers.

And now here he is as a teacher of design, submitting to the task of creating particular decorative motifs, expounding his personal ideas and ideals by means of examples drawn from his own production. Doubtless this collec-

tion of hitherto unpublished "Documents décoratifs" will be studied with pleasure, as it deserves to be, and the study will certainly be profitable in a practical way to those for whom it is intended. If the lessons it contains are somewhat special in nature, they nevertheless constitute a useful body of instruction. First of all, they comprise an example that deserves to be strictly followed as to its point of departure; I mean, as to the conscientious, respectful, humble and reverent observation of nature that is everywhere in evidence, not only in the plates of realistic studies, but also in the decorative combinations deriving therefrom. Certain plates, therefore, seem to me to be especially valuable: those which show the closest connection between the realistic document drawn directly from nature and the interpretation of that document, the conscious utilization of it that the designer makes. In this respect, I feel that a collection like this one is bound to be of great service because all the models it contains display a striving for balance and harmony. So that, in addition to the specimens of flat ornament to be found here, there are also numerous examples of three-dimensional ornament and studies of form worthy of the closest attention.

Here, for example, are works in silver, some of which, as modern as they are, will strike all people of good taste as being excellent (Plates* 4, 5, 6, 7, 70). Here are curious objects of wrought metal (Plates 21, 59): andirons, fire tongs and shovels; designs for a chandelier, an electric lamp and a petroleum lamp. There are designs for jewelry (Plates 28, 29, 48); an item of furniture (Plate 37) with certain extremely interesting details. In a quite different category, there are exquisite motifs for lace and for embroidered and appliquéd muslin (Plates 38, 39), not to mention those amusing friezes of fish (Plate 23) or squirrels, cockatoos and pigeons (Plate 33), that appealing decor of fuchsias (Plate 1) and that chaste panel of lilies (Plate 53); not to mention that series of decorative human figures of such a personal charm, examples of a genre in which the artist is universally known to excel. The same qualities I mentioned at the outset of this foreword emerge here and there: rich vision, imaginative interpretation, exotic perfume, feminine charm, subtlety, delicate stylization. Mucha never tortures flowers when he stylizes them; he likes them too well to harm them; his love for them is too passionate to inflict the slightest injury on them. Perhaps here more than anywhere else can be felt the vitality of the principles on which the personality of this brilliant artist has been based in its development.

In fact, according to him, decorative art consists entirely in the heightening of the significance of line, form and material; the chief aim of ornamentation for him is giving life to matter, spiritualizing it. In all periods, decorative art has been founded on the study of nature; if

in recent days we have seen the emergence of certain eccentricities that have never occurred before, it is because at present the study of natural forms is not sufficiently widespread—for everything in nature is balance and harmony, and all the interrelations of things are logical. At the point we have reached, in light of the miraculous, inexhaustible heritage from the past, seeing that all possible forms have been found and used, one thing only is left to us: our modern vision of nature, infinitely more insightful, intelligent, refined and subtle than in the past —and, in any case, our own, that of twentieth-century man. The only role the designer can play today is to modify, spiritualize and stylize existing forms in accordance with our personal perception of nature.

Still speaking in line with Mucha's tenets: there are traditional laws of the sense of line that are peculiar to each large human group, to each race; and history shows that every time some reason or other has led artists to violate these laws, only disorder, madness and error have resulted. Line is like the handwriting that reveals the degree of evolution of the individual; the same holds for the sense of line in nations. The Germanic races prefer jagged, broken lines; the curved line is characteristic of the Byzantines and Latins. Any art based on combinations of lines contrary to these laws can only be artificial; it cannot come to the fore, nor can it last, because it is in direct and total opposition to the very genius of the race. No matter what happens, we in France will never be contented with the interplay of jagged lines; they hurt our eyes. On the other hand, all art based on curved lines sets us at ease. The same is true for the Slavic race; hence the affinities that exist and will always exist between that race and ours: we both love the same lines.

This is not the place to discuss whether Mucha is right or wrong, whether the facts justify these theories of his or not. I have only mentioned these ideas that he regularly expounds, and seem to be very dear to him, in order to show that, in contrast to so many of his colleagues who practice their art without a philosophical basis, he possesses set notions and precise ideas on the future, the goal and the mission of decorative art. If these solid principles do not suffice to make an artist, they are powerful aids to the development of the talents and the instinct without which that privileged being cannot exist. The time is near when what might be called the science of art will be common knowledge; will the number of true creators of beauty be greater because of it? Nothing is less likely; no matter what perfection is attained in the teaching of the fine arts and letters, those who are able to observe nature and life on their own and to transcribe in original and new forms the sensations, visions and ideas they have derived from that contemplation, will always remain magnificent and admirable exceptions. The poet and the artist are the only two flowers whose blossoming cannot be induced or hastened by human willpower.

---

* The plate numbers are those of the present edition; see Concordances for original numbers.

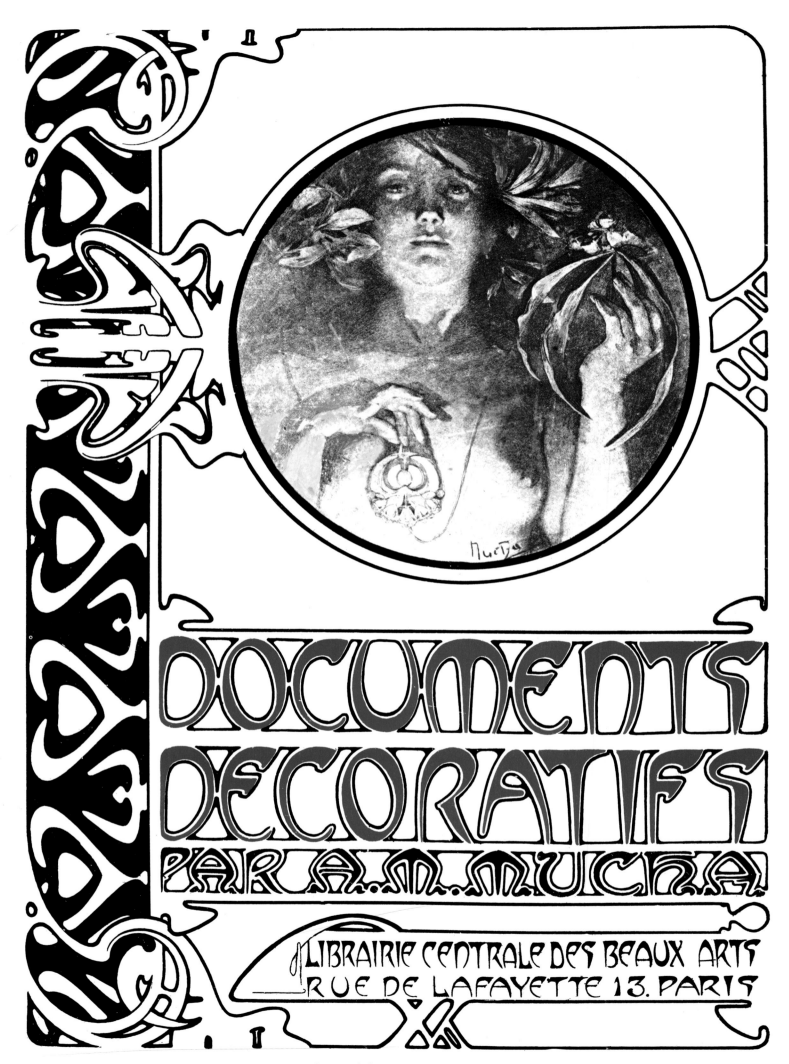

DOCUMENTS
DECORATIFS
PAR A. M. MUCHA

LIBRAIRIE CENTRALE DES BEAUX ARTS
RUE DE LAFAYETTE 13. PARIS

Cover of the original portfolio

# Concordances
## Between Old & New Plate Numbers

| Dover Edition | Original Edition | Dover Edition | Original Edition | Dover Edition | Original Edition | Original Edition | Dover Edition | Original Edition | Dover Edition | Original Edition | Dover Edition |
|---|---|---|---|---|---|---|---|---|---|---|---|
| 1 | 40 | 25 | 7 | 49 | 46 | 1 | 27 | 25 | 8 | 49 | 48 |
| 2 | 6 | 26 | 2 | 50 | 13 | 2 | 26 | 26 | 47 | 50 | 29 |
| 3 | 11 | 27 | 1 | 51 | 14 | 3 | 30 | 27 | 61 | 51 | 28 |
| 4 | 58 | 28 | 51 | 52 | 36 | 4 | 42 | 28 | 16 | 52 | 38 |
| 5 | 65 | 29 | 50 | 53 | 33 | 5 | 24 | 29 | 11 | 53 | 39 |
| 6 | 61 | 30 | 3 | 54 | 56 | 6 | 2 | 30 | 13 | 54 | 18 |
| 7 | 59 | 31 | 31 | 55 | 57 | 7 | 25 | 31 | 31 | 55 | 57 |
| 8 | 25 | 32 | 32 | 56 | 42 | 8 | 44 | 32 | 32 | 56 | 54 |
| 9 | 45 | 33 | 35 | 57 | 55 | 9 | 19 | 33 | 53 | 57 | 55 |
| 10 | 41 | 34 | 20 | 58 | 69 | 10 | 45 | 34 | 63 | 58 | 4 |
| 11 | 29 | 35 | 17 | 59 | 68 | 11 | 3 | 35 | 33 | 59 | 7 |
| 12 | 39 | 36 | 71 | 60 | 23 | 12 | 43 | 36 | 52 | 60 | 23 |
| 13 | 30 | 37 | 64 | 61 | 27 | 13 | 50 | 37 | 40 | 61 | 6 |
| 14 | 47 | 38 | 52 | 62 | 43 | 14 | 51 | 38 | 72 | 62 | 70 |
| 15 | 48 | 39 | 53 | 63 | 34 | 15 | 68 | 39 | 12 | 63 | 21 |
| 16 | 28 | 40 | 37 | 64 | 21 | 16 | 69 | 40 | 1 | 64 | 37 |
| 17 | 72 | 41 | 67 | 65 | 22 | 17 | 35 | 41 | 10 | 65 | 5 |
| 18 | 54 | 42 | 4 | 66 | 19 | 18 | 67 | 42 | 56 | 66 | 71 |
| 19 | 9 | 43 | 12 | 67 | 18 | 19 | 66 | 43 | 62 | 67 | 41 |
| 20 | 70 | 44 | 8 | 68 | 15 | 20 | 34 | 44 | 22 | 68 | 59 |
| 21 | 63 | 45 | 10 | 69 | 16 | 21 | 64 | 45 | 9 | 69 | 58 |
| 22 | 44 | 46 | 24 | 70 | 62 | 22 | 65 | 46 | 49 | 70 | 20 |
| 23 | 60 | 47 | 26 | 71 | 66 | 23 | 60 | 47 | 14 | 71 | 36 |
| 24 | 5 | 48 | 49 | 72 | 38 | 24 | 46 | 48 | 15 | 72 | 17 |

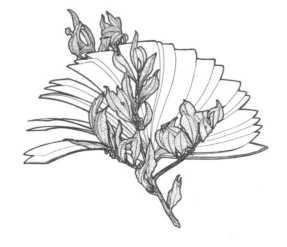

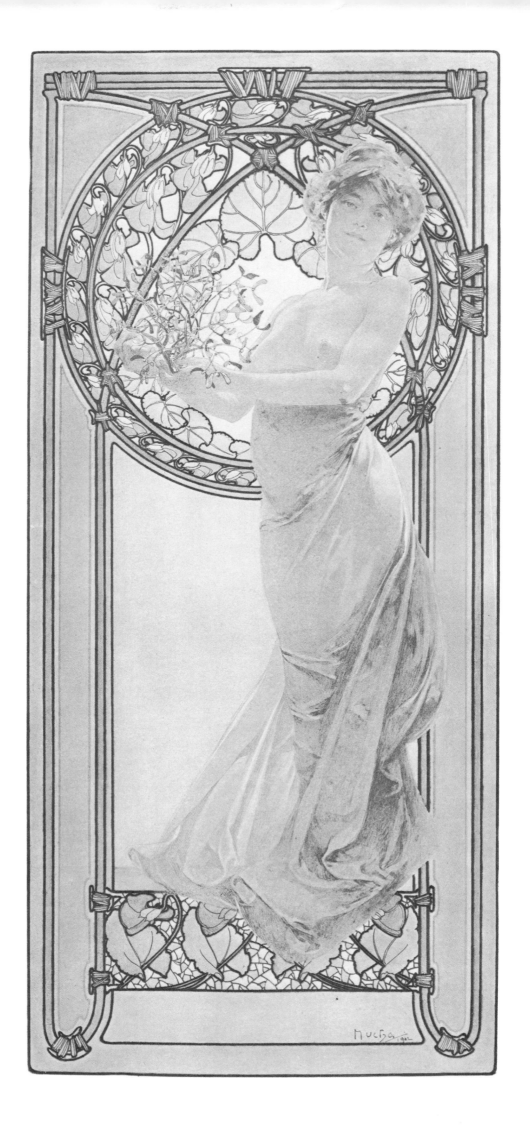

PLATE 3

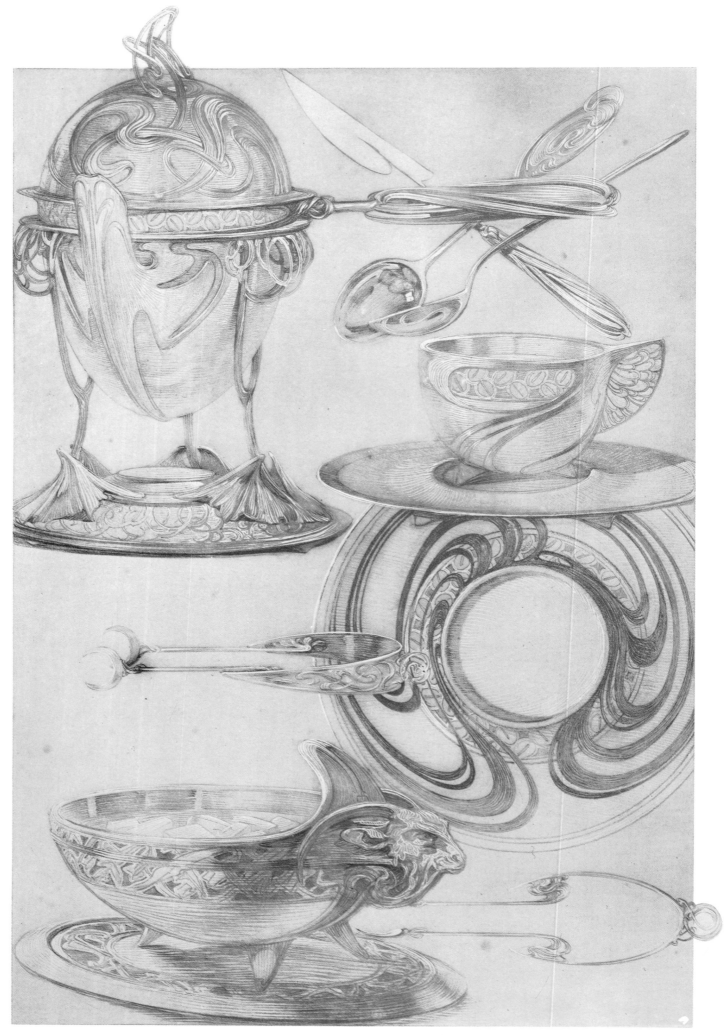

PLATE 4

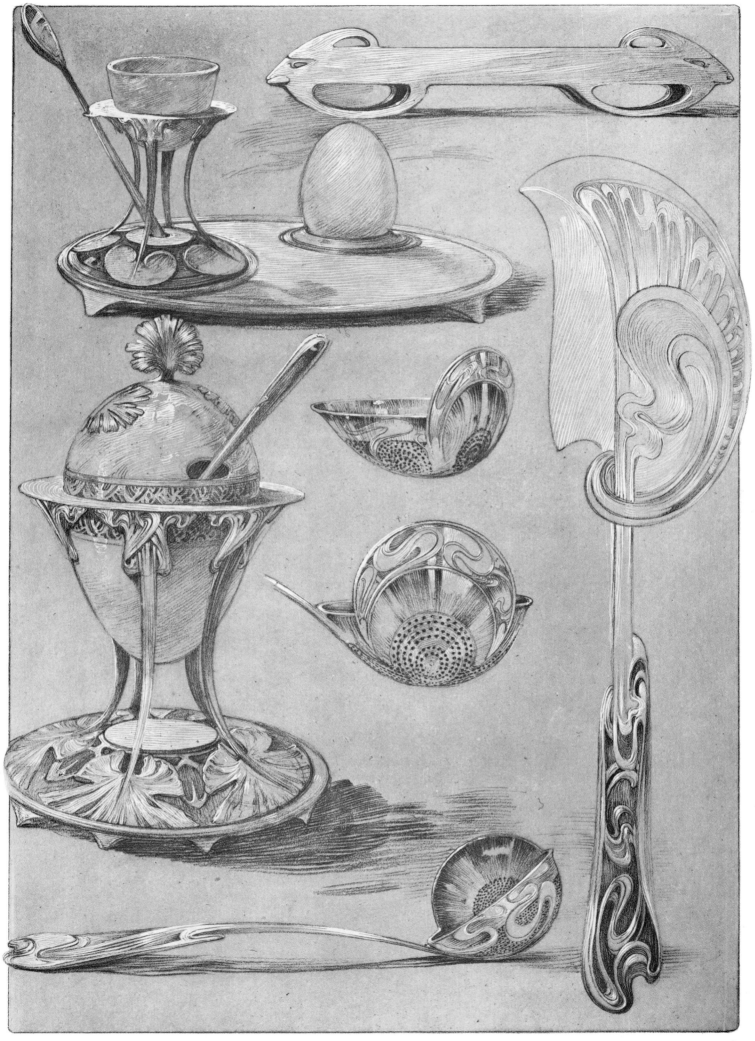

PLATE 5

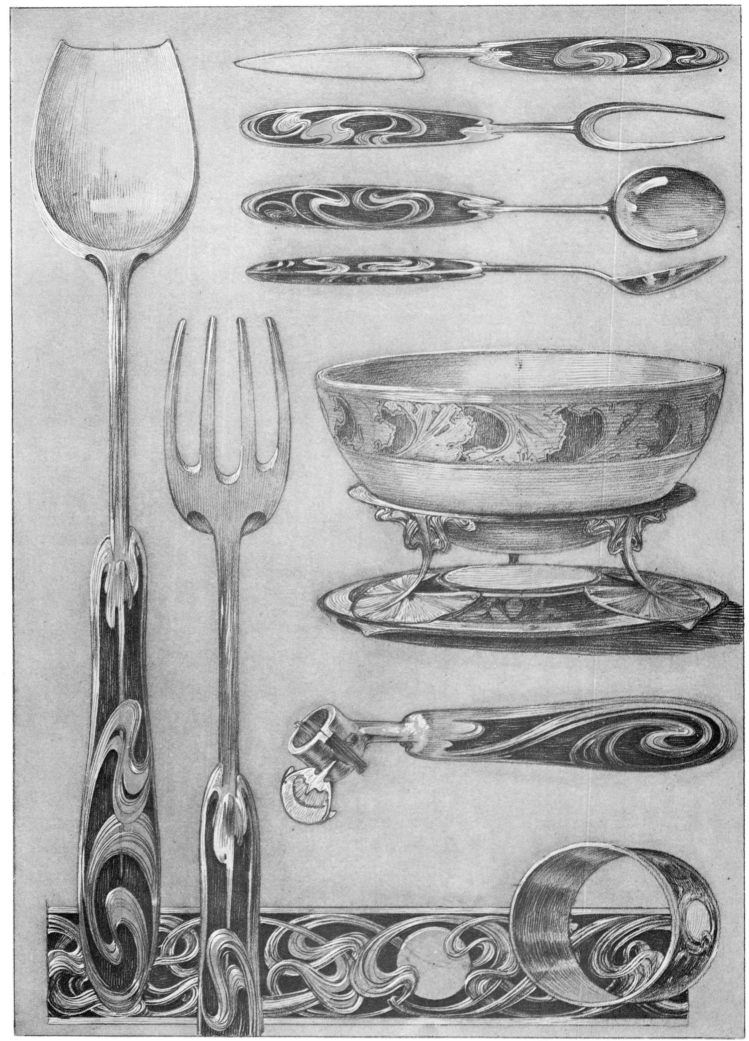

Plate 6

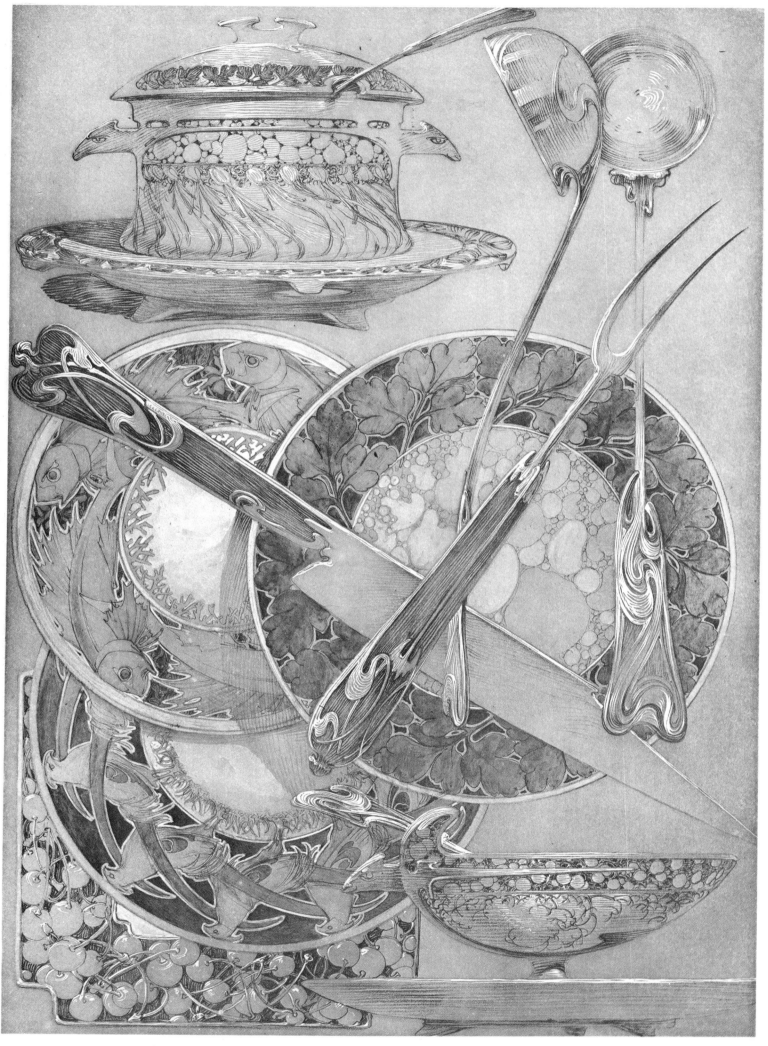

Plate 7

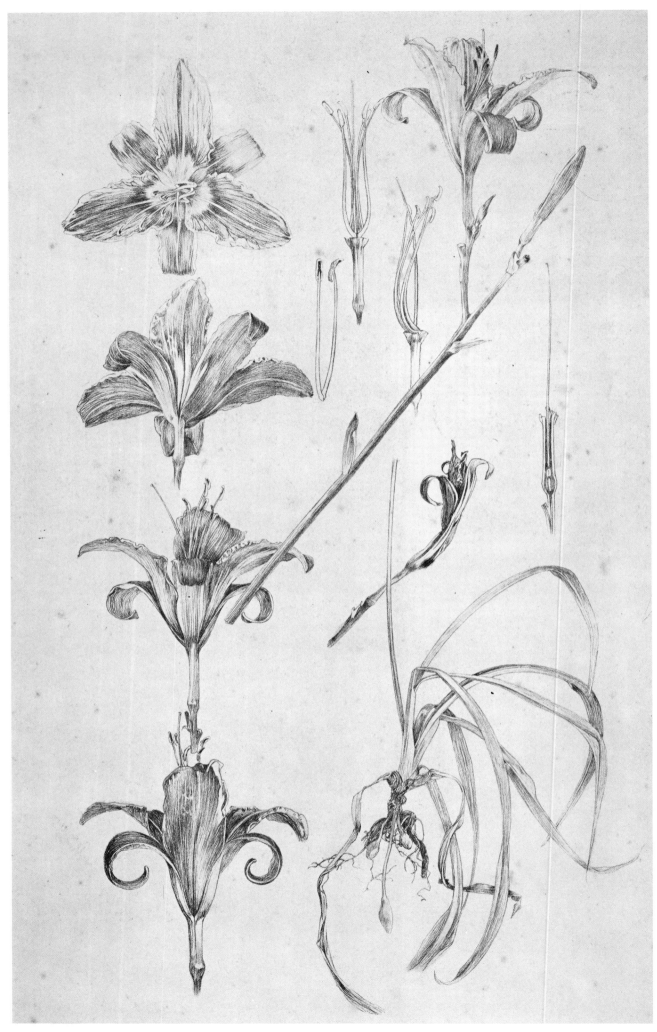

Plate 8

Hémérocalle ou Lys asphodèle (Day lily)

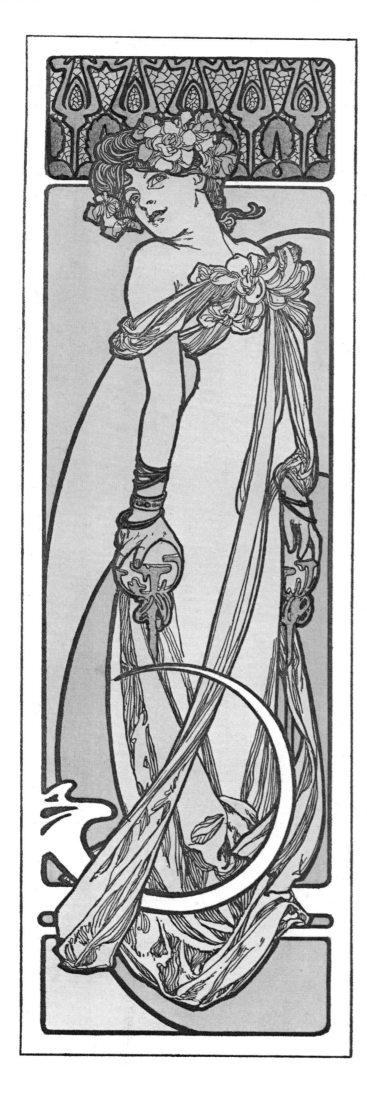
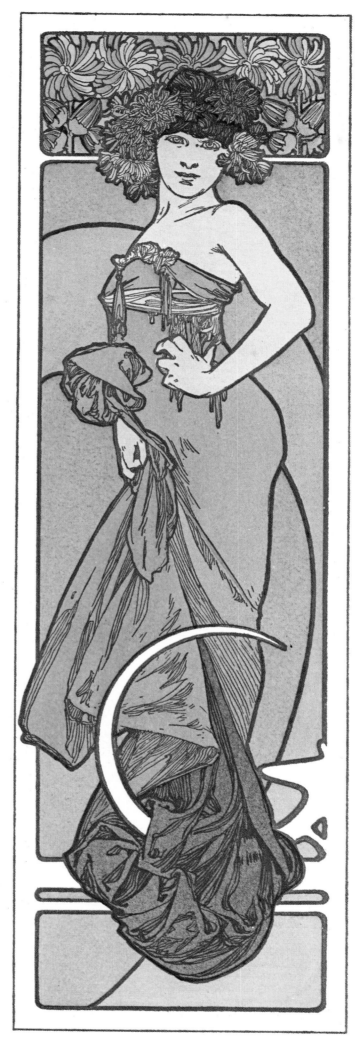

PLATE 9

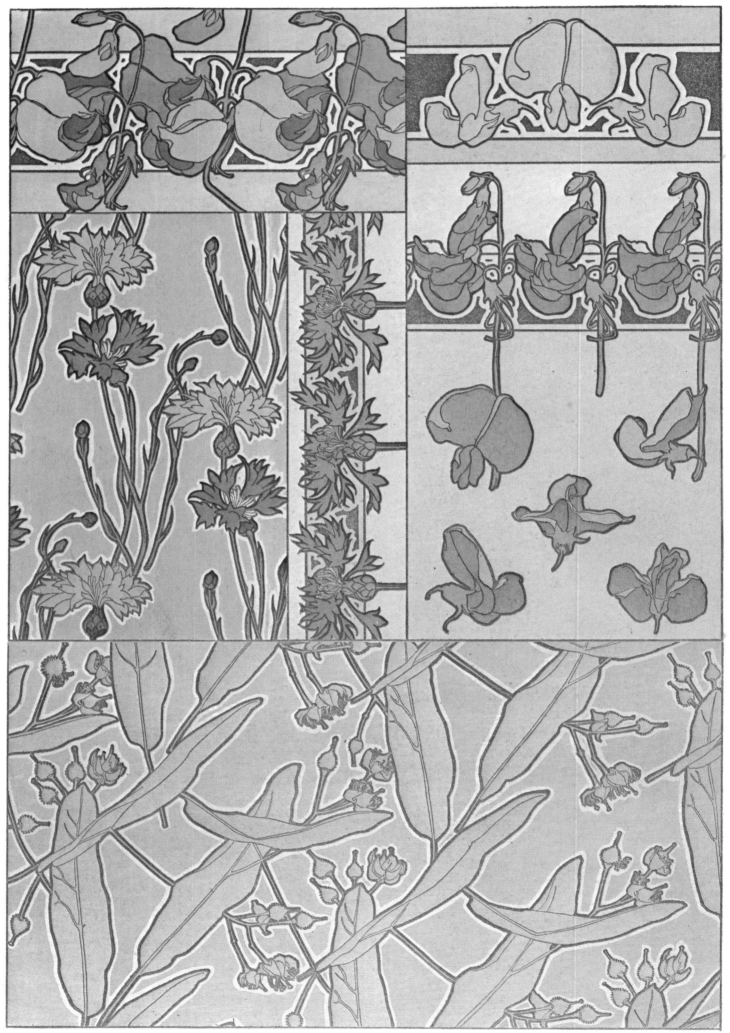

PLATE 10

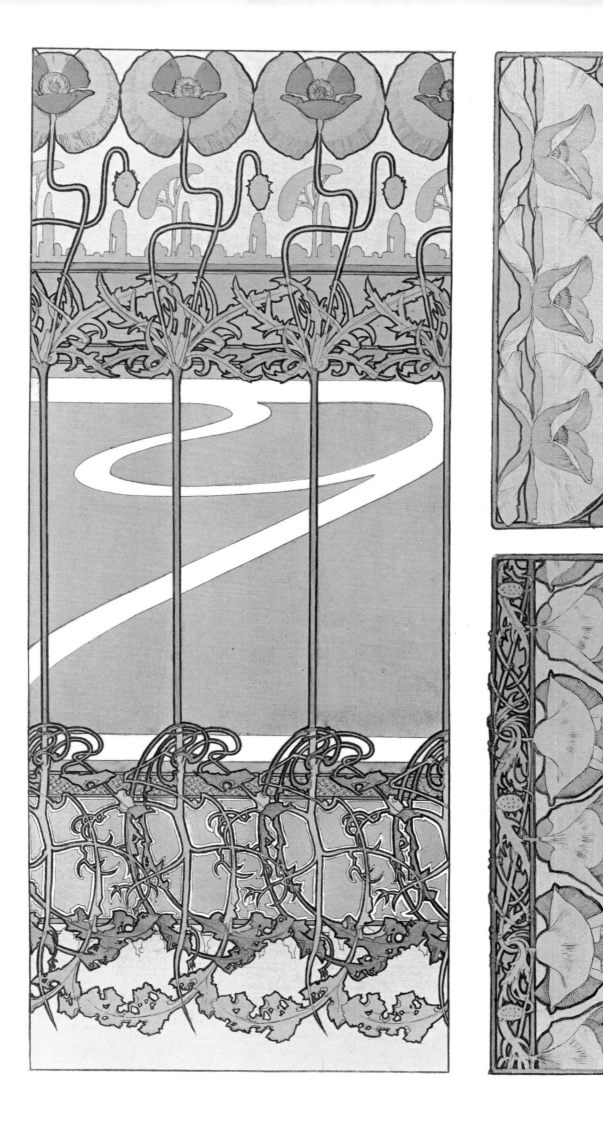

PLATE 11

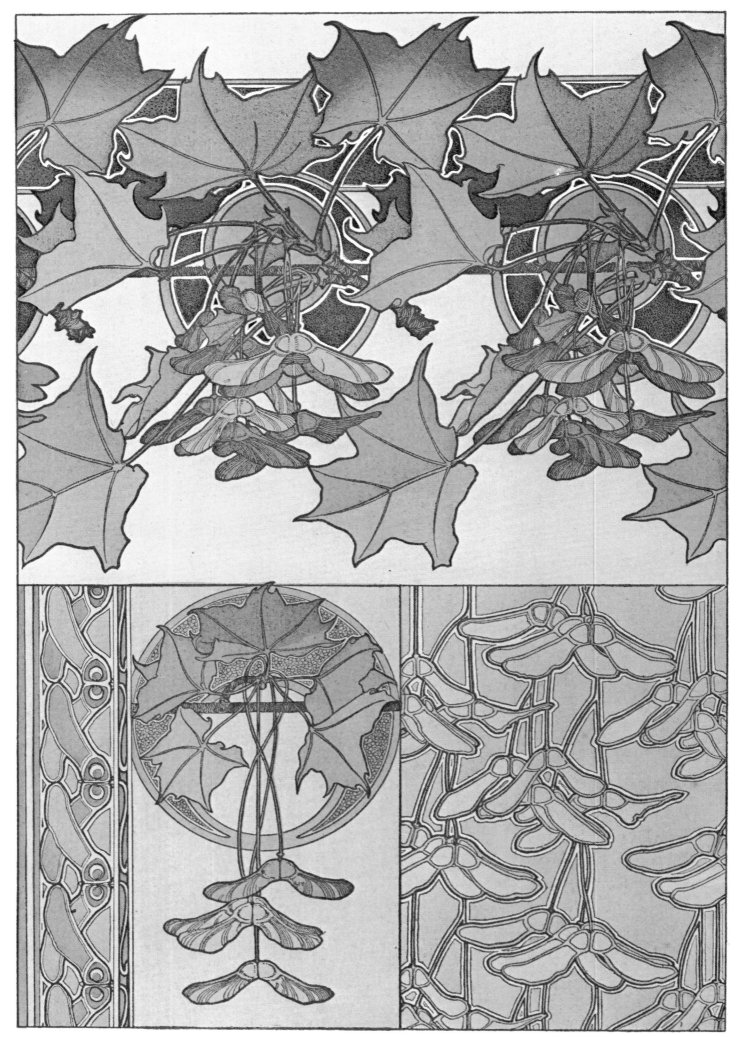

PLATE 12

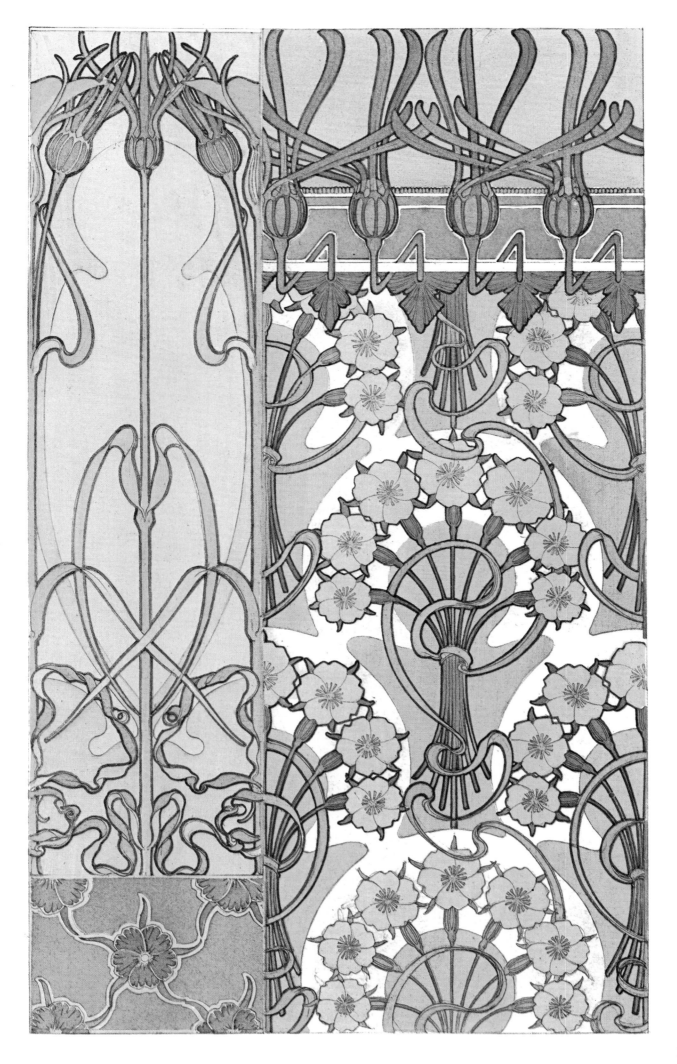

PLATE 13

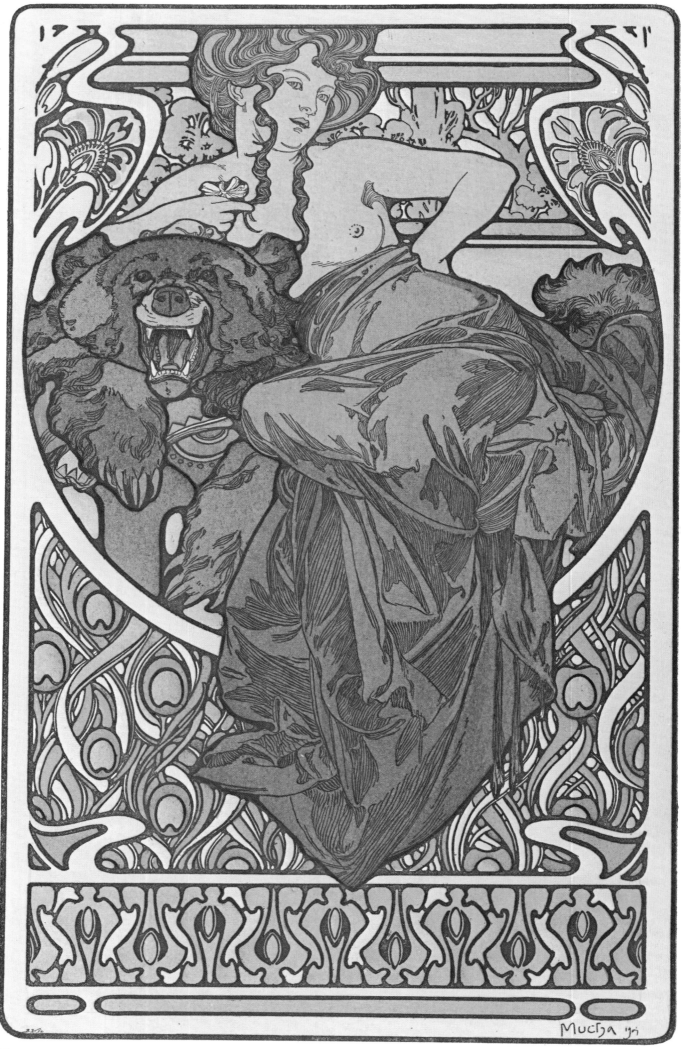

Plate 14

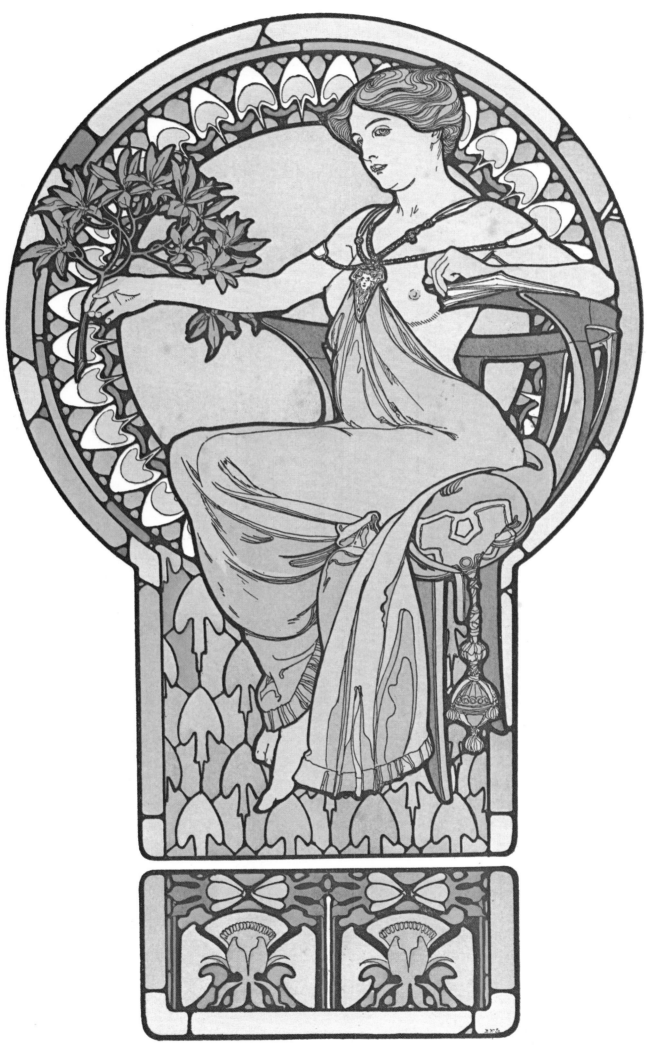

PLATE 15

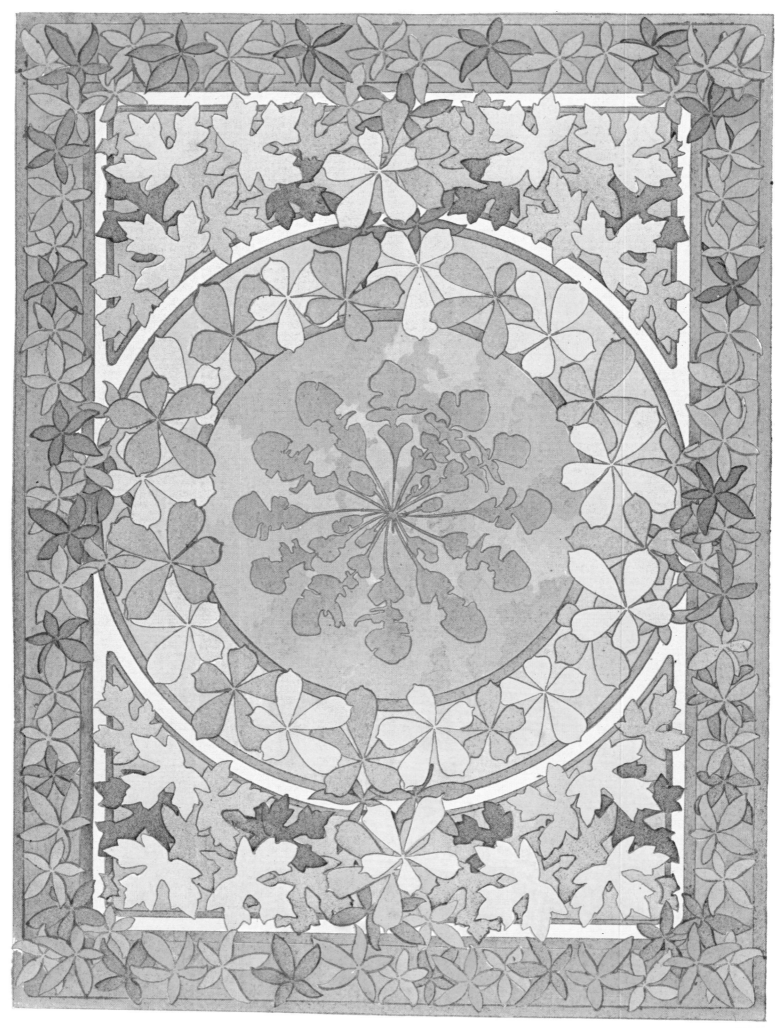

PLATE 16

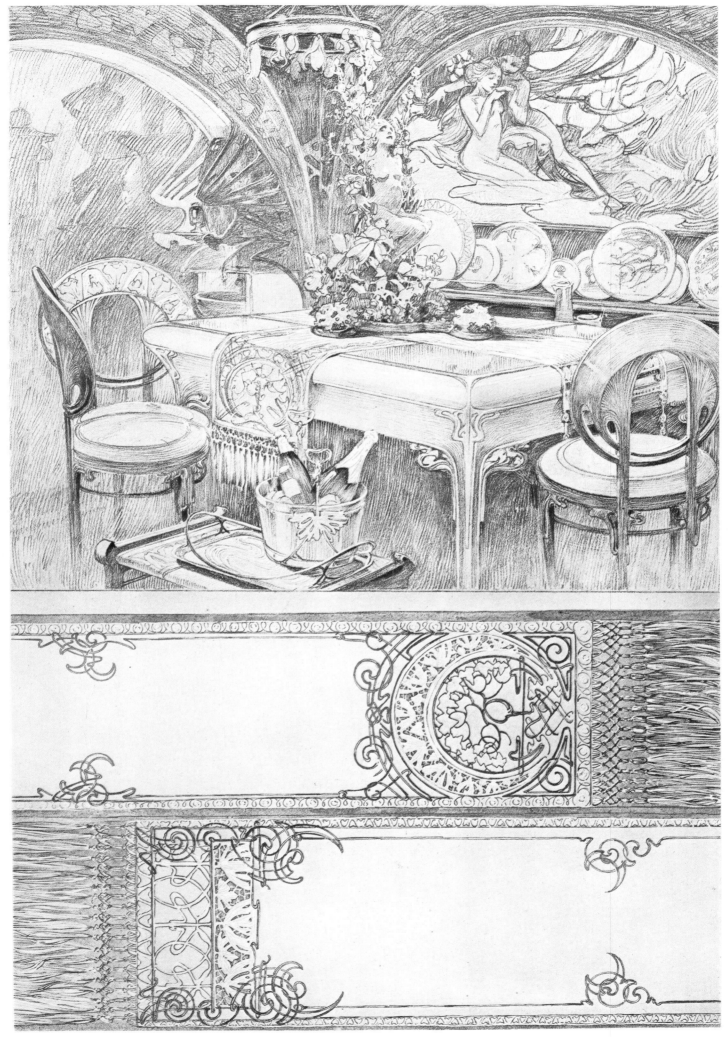

PLATE 17

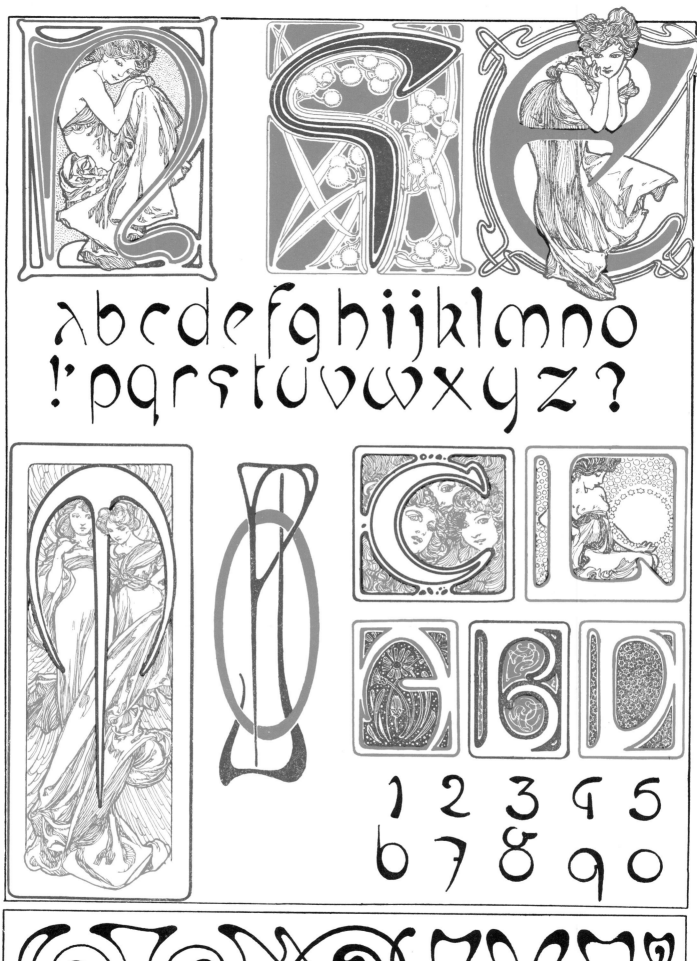

abcdefghijklmno
!'pqrstuvwxyz?

1 2 3 4 5
6 7 8 9 0

PLATE 18

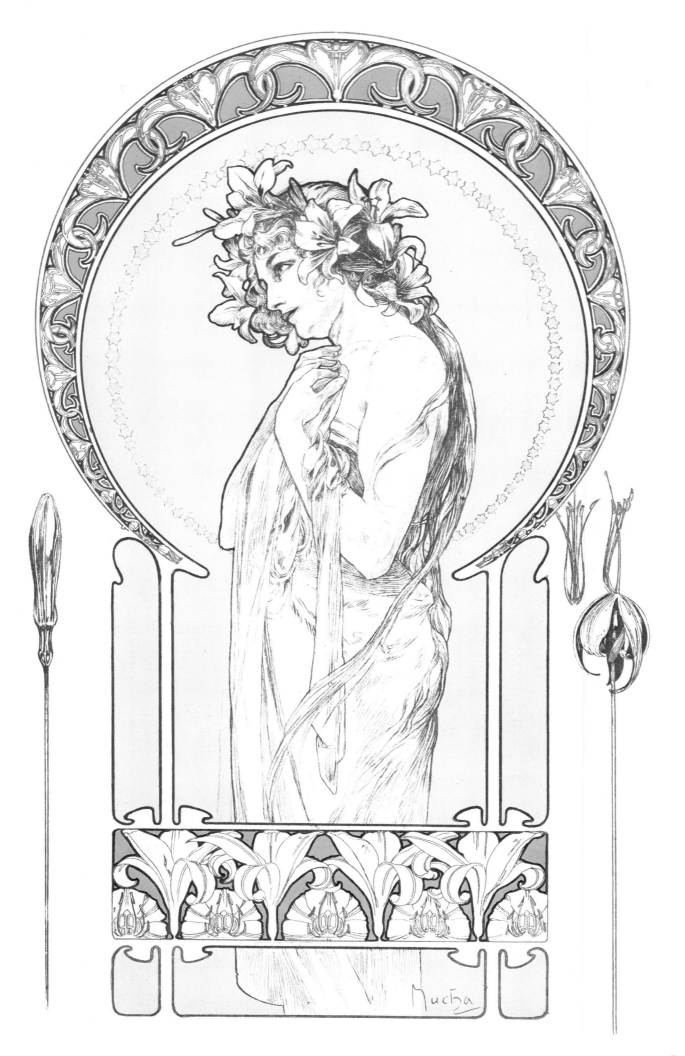

PLATE 19

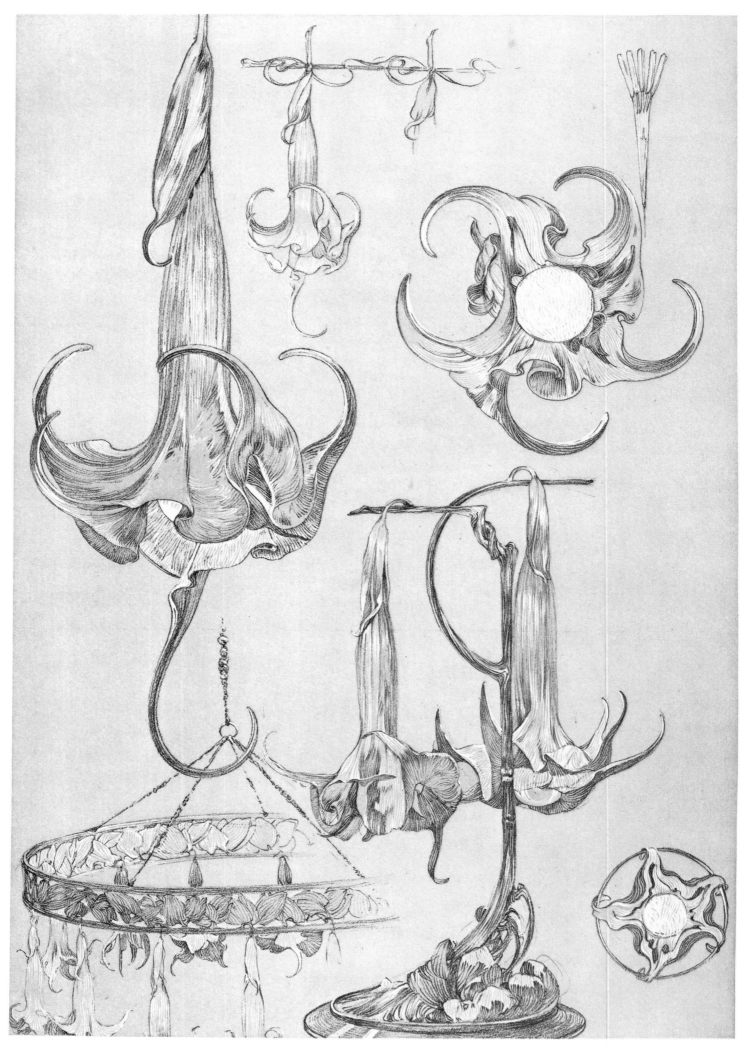

Plate 20

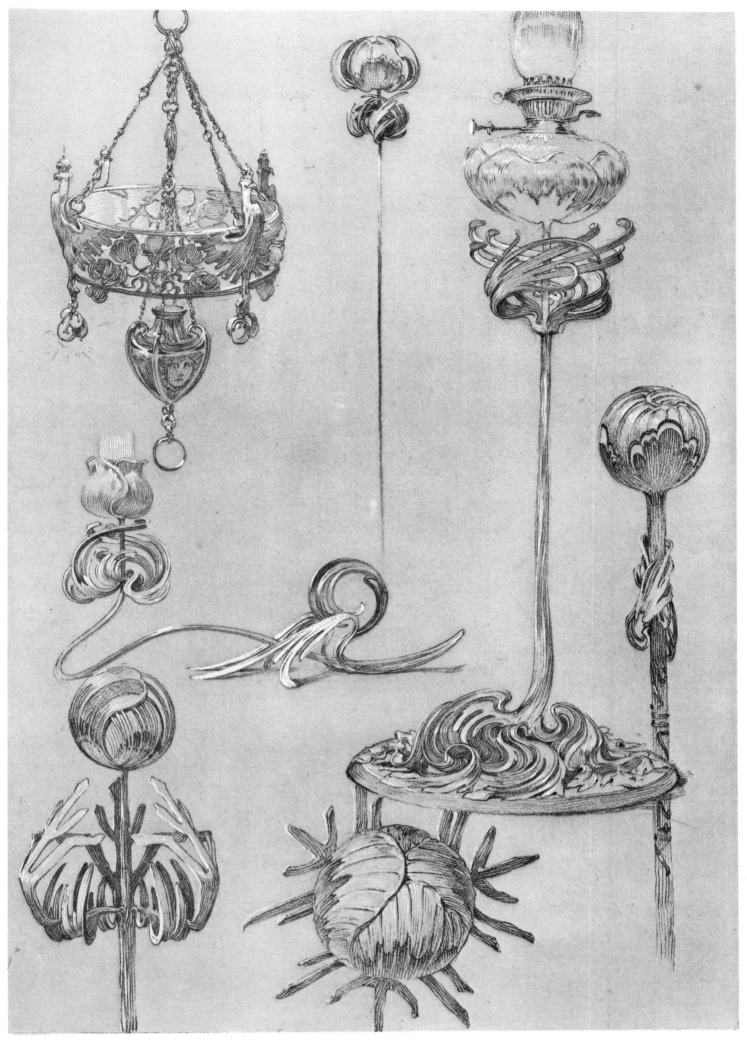

PLATE 21

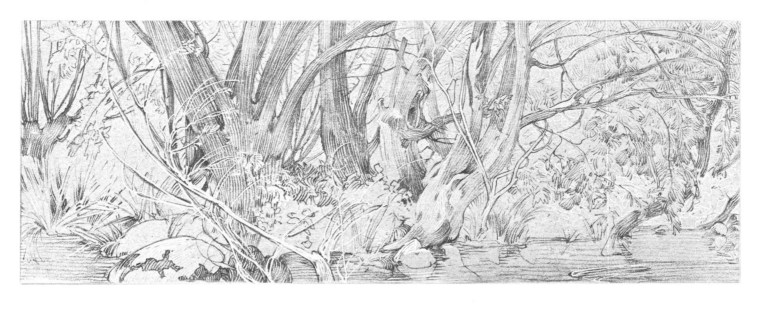

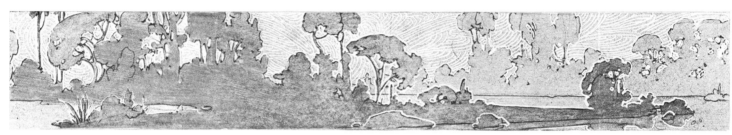

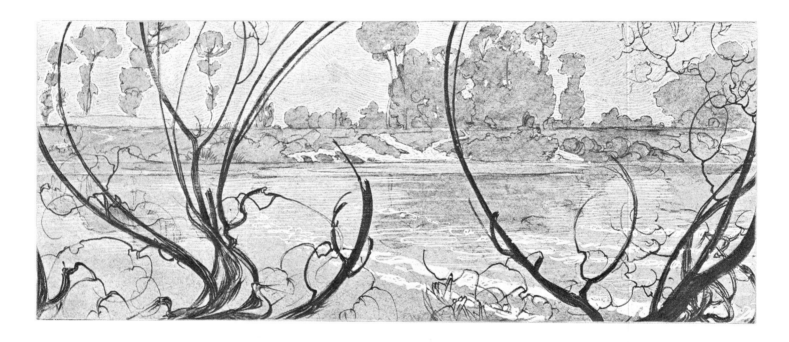

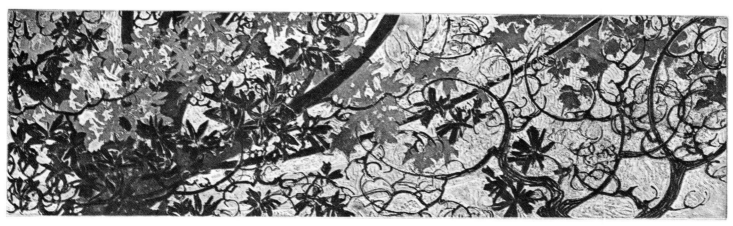

Plate 22

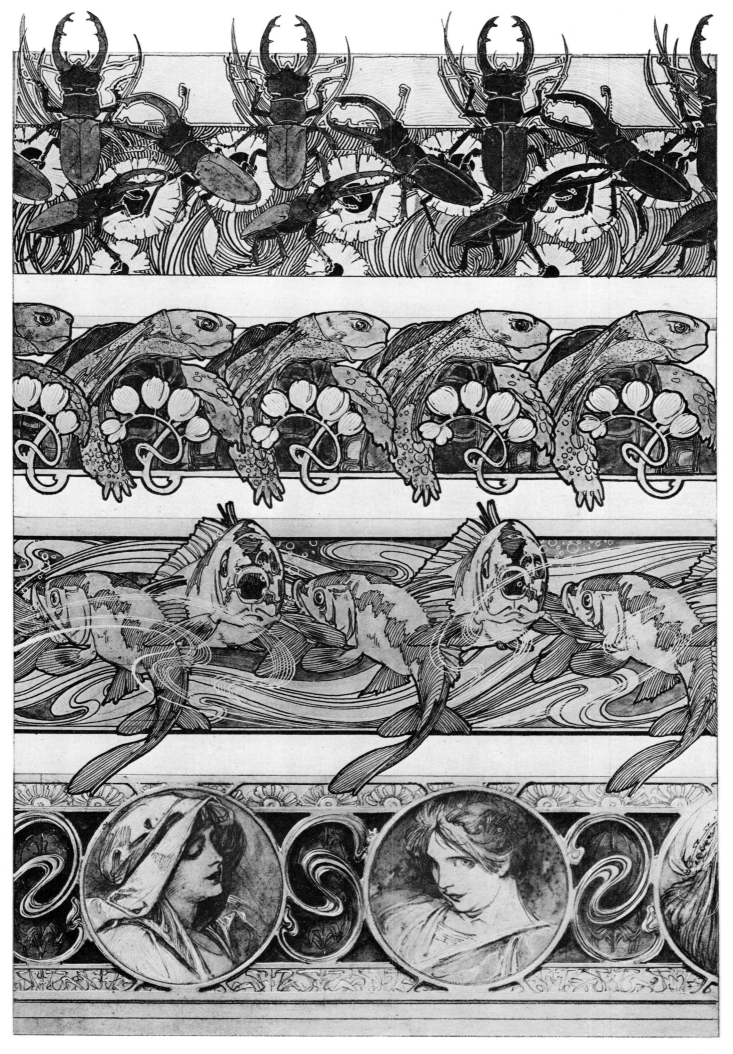

PLATE 23

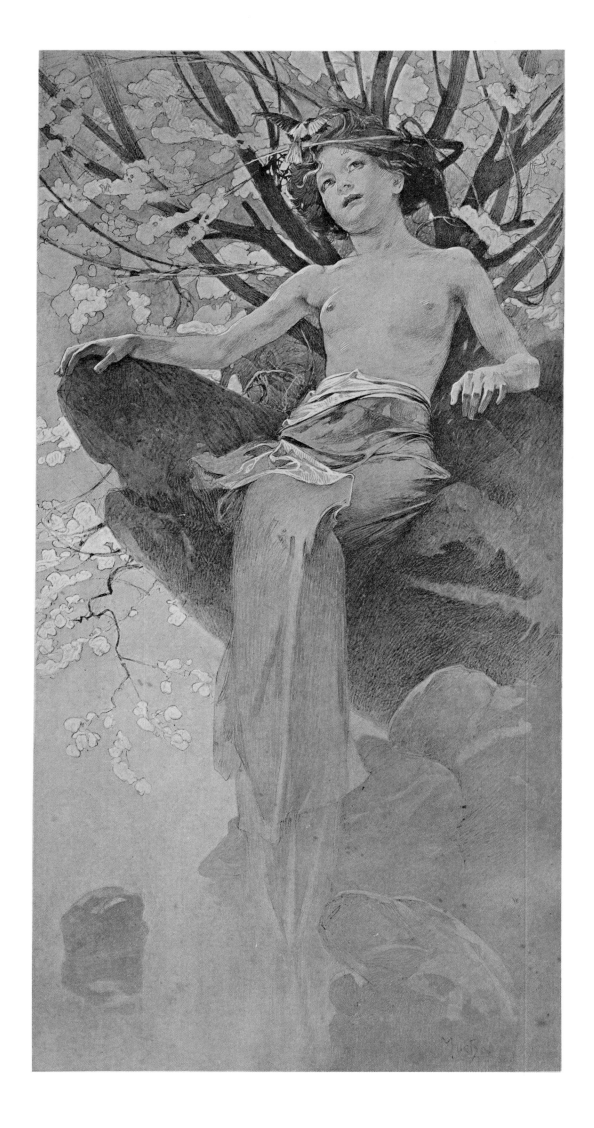

PLATE 24

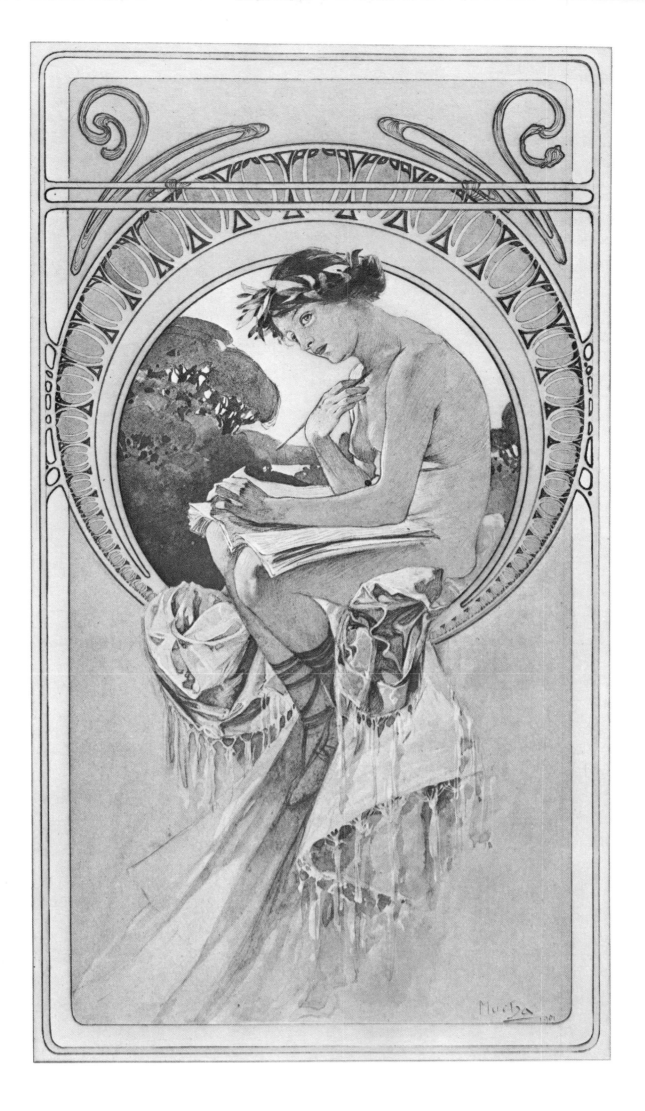

PLATE 25

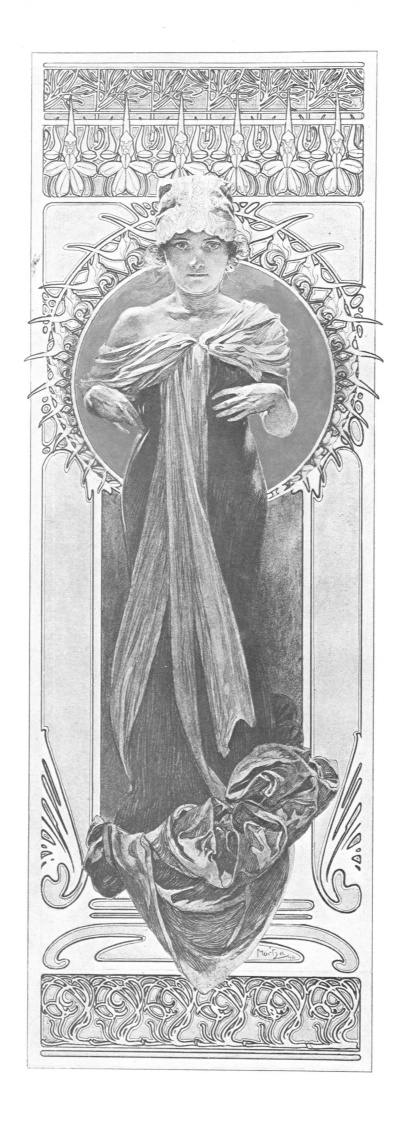

PLATE 26

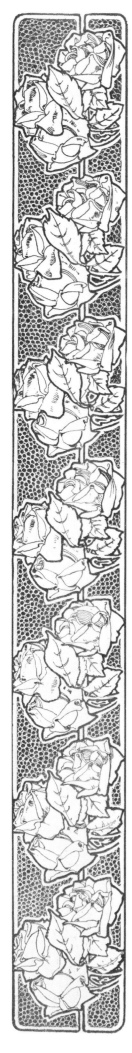

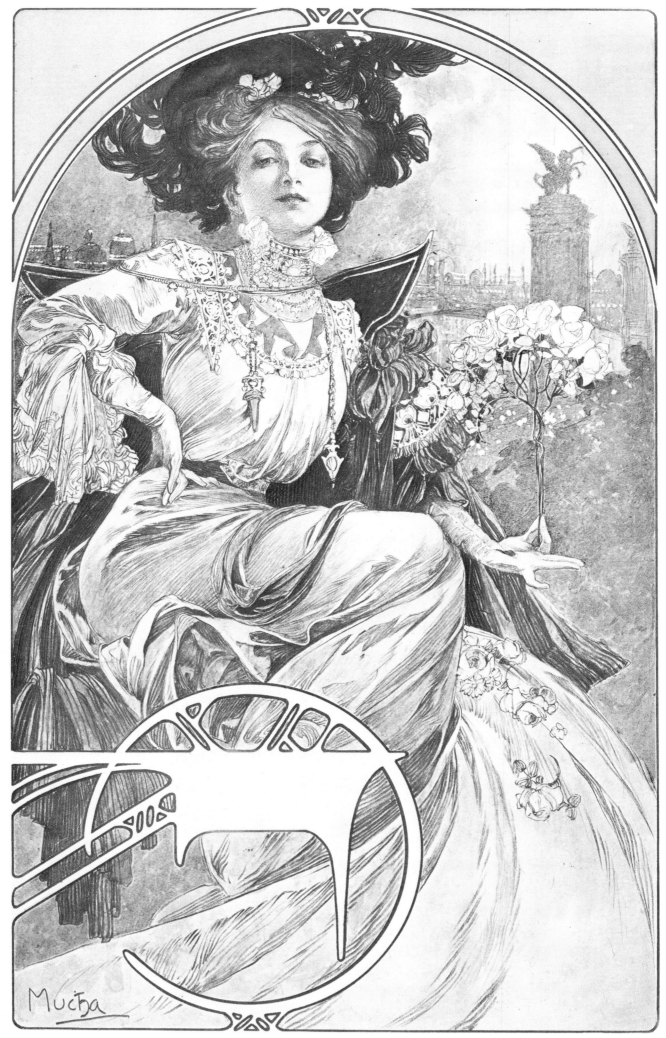

Mucha

PLATE 27

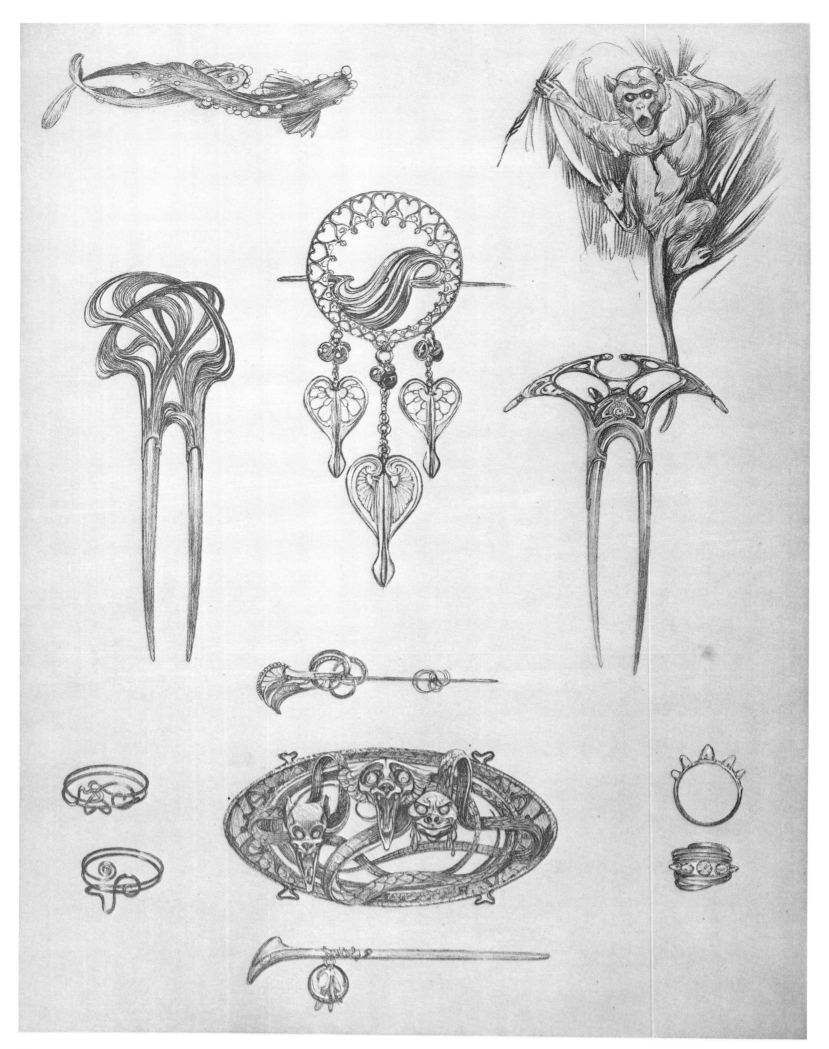

PLATE 28

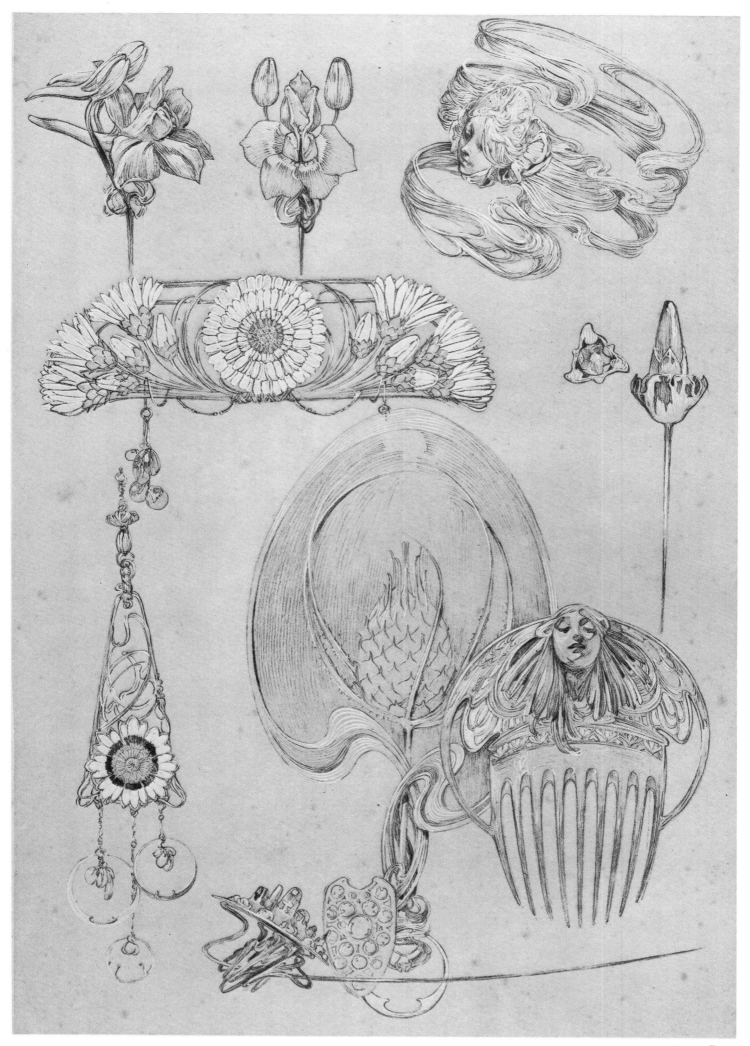

Plate 29

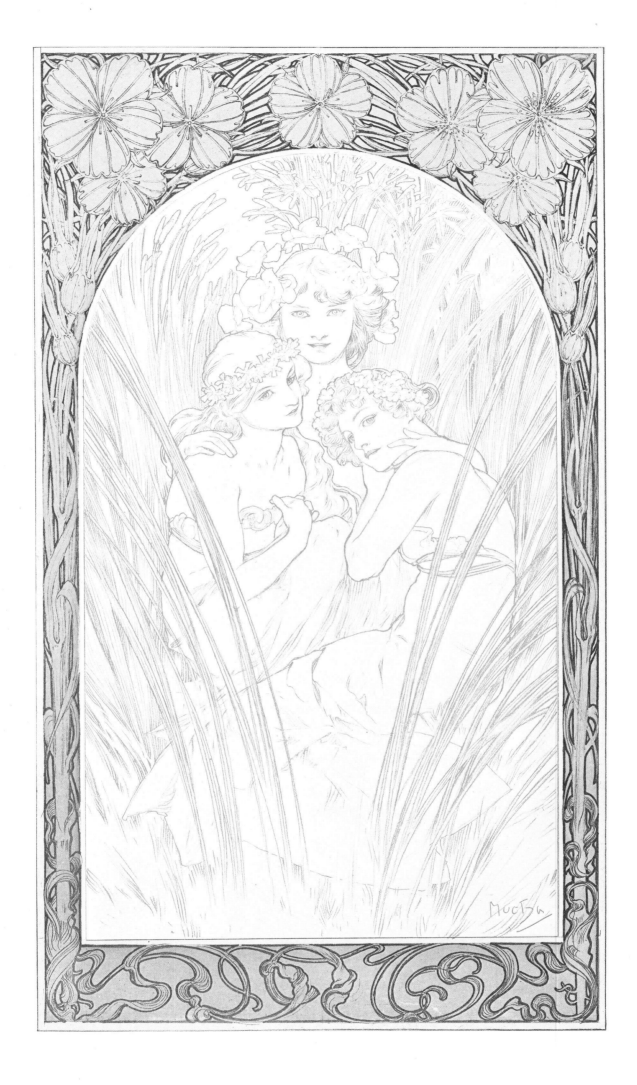

PLATE 30

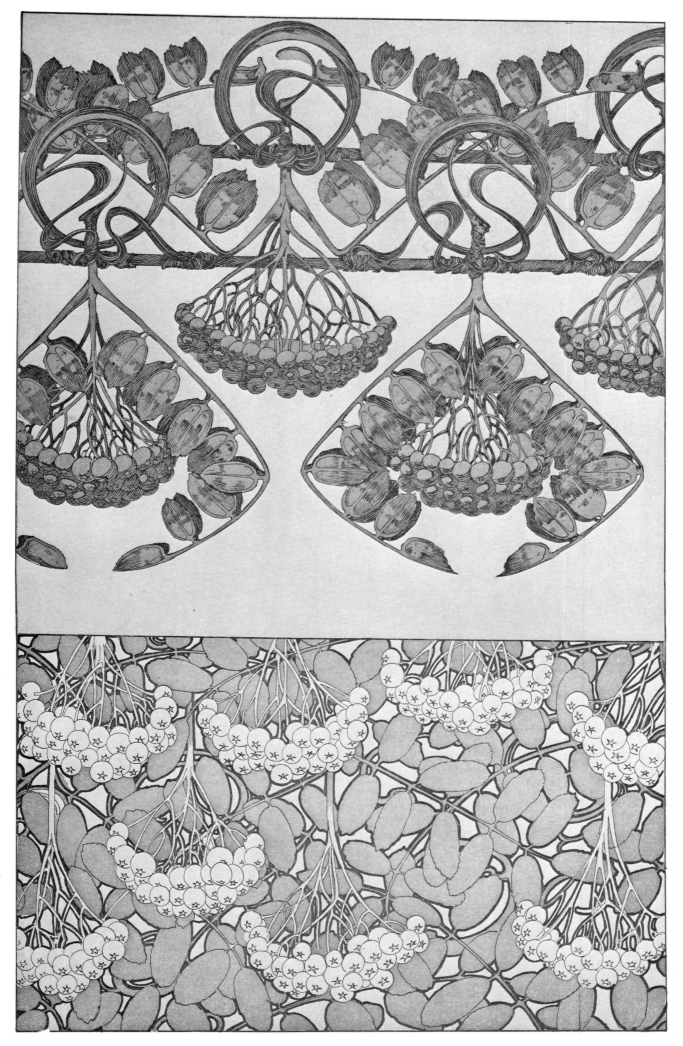

Plate 31

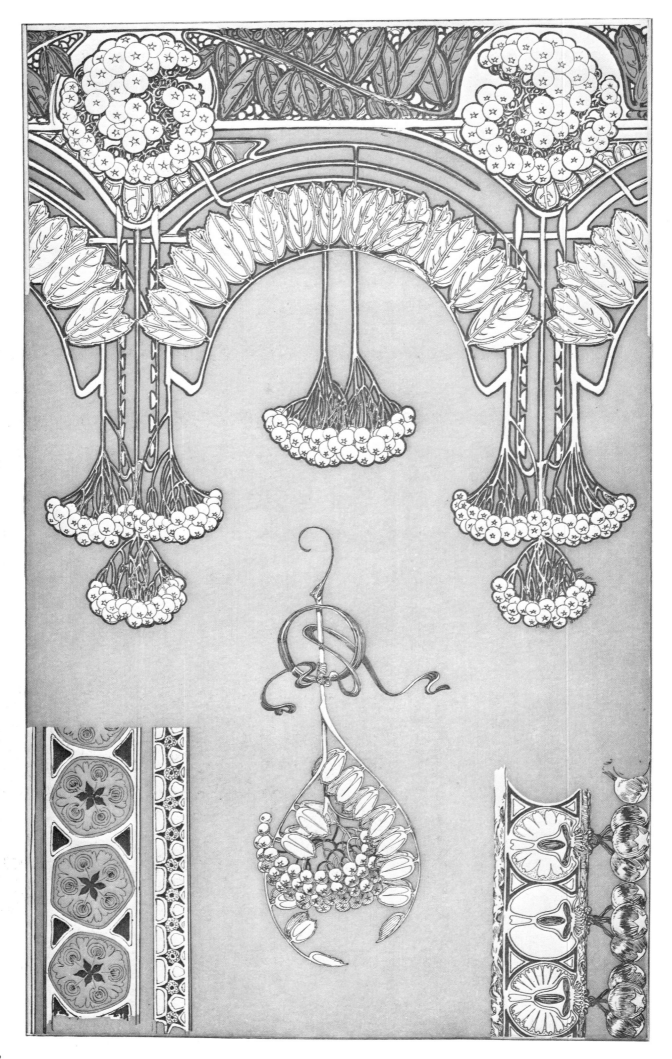

PLATE 32

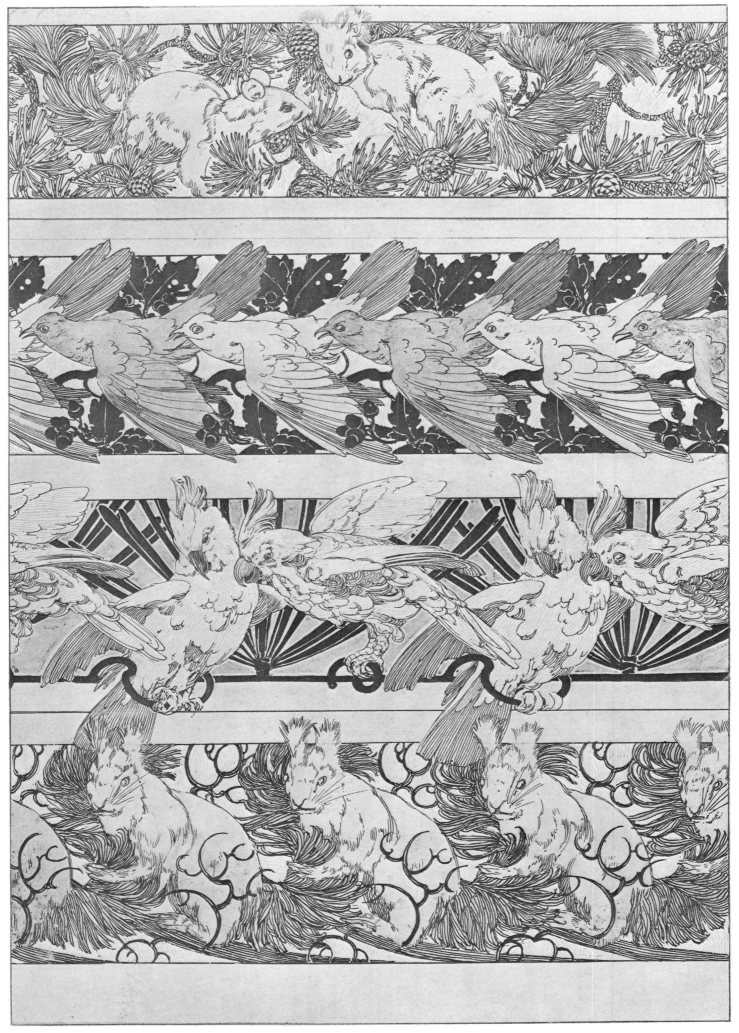

PLATE 33

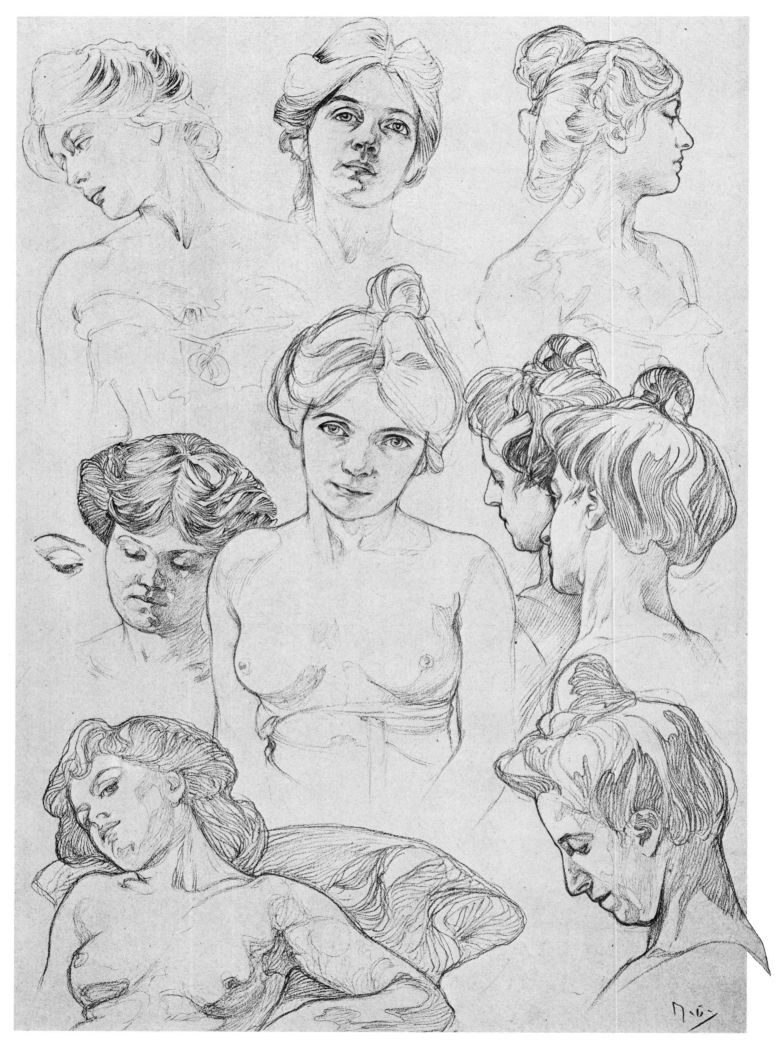

PLATE 34

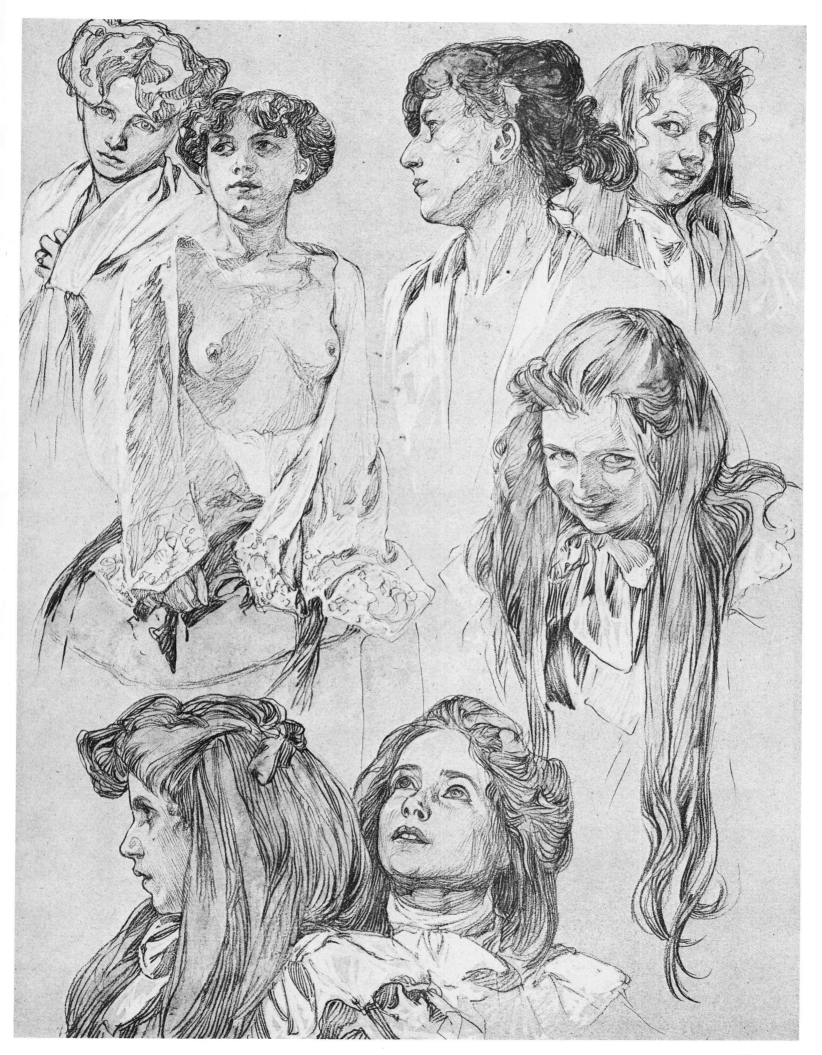

PLATE 35

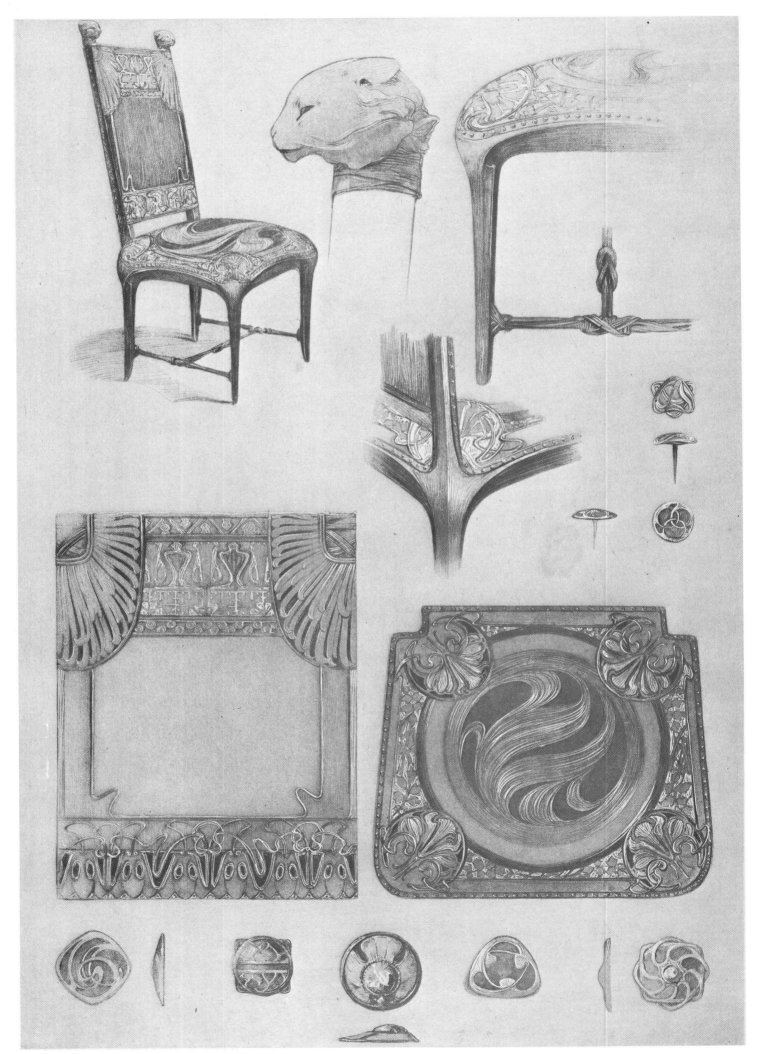

Plate 36

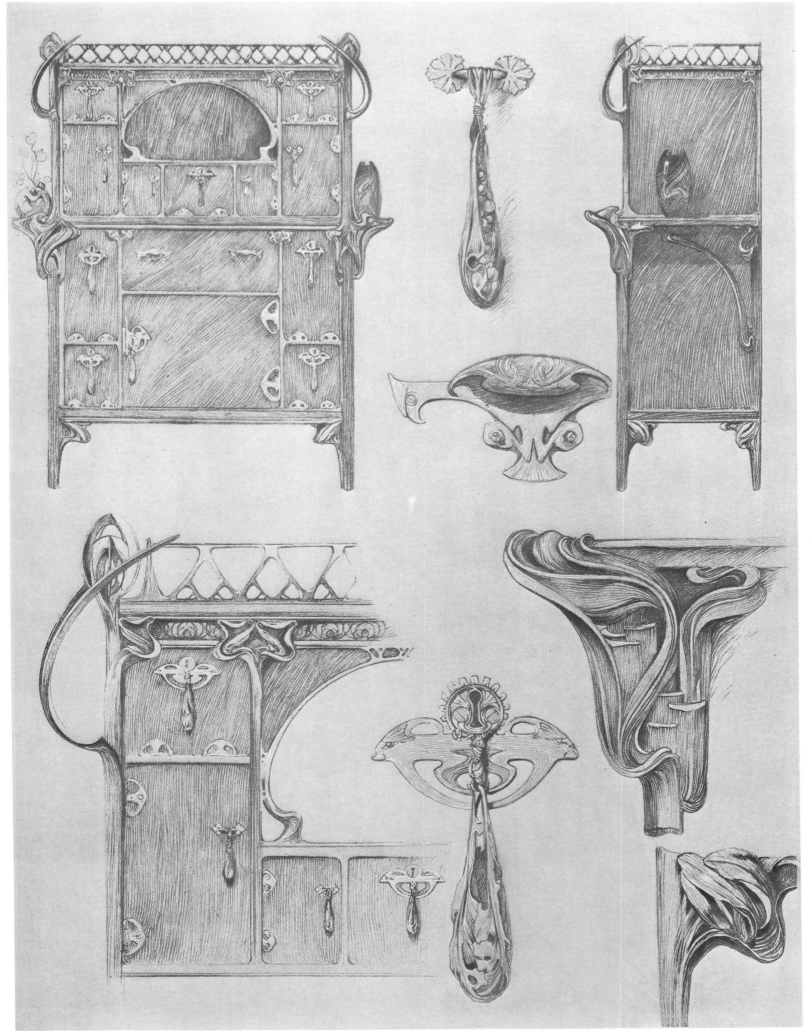

PLATE 37

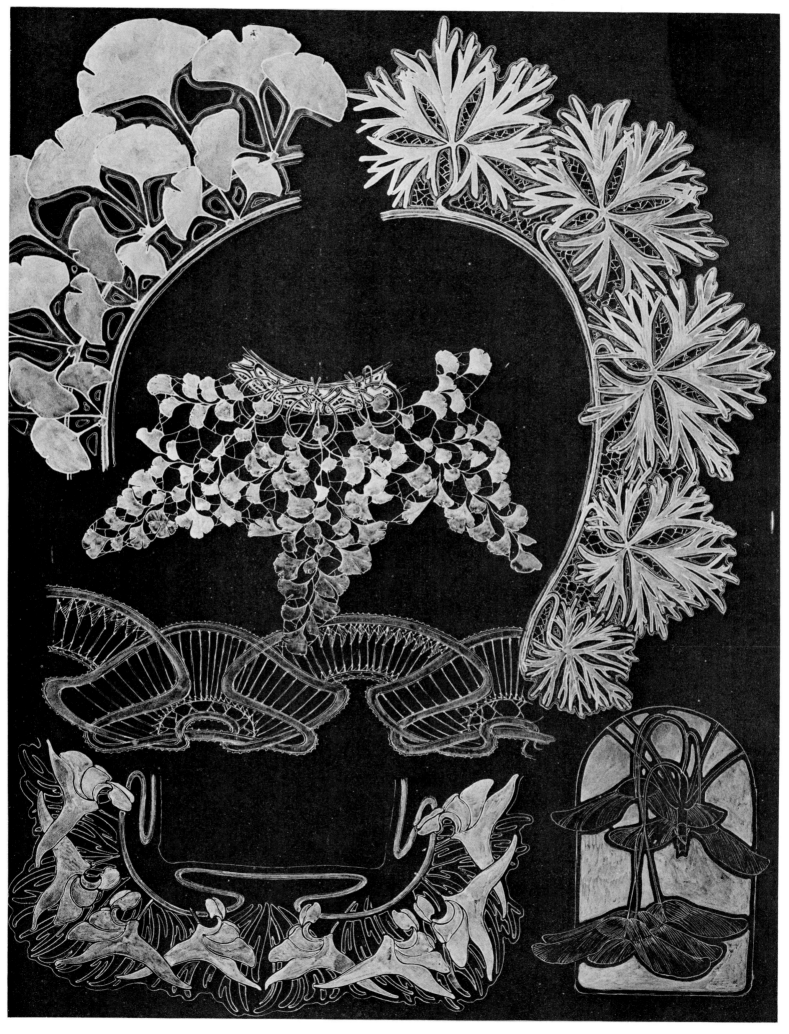

PLATE 38

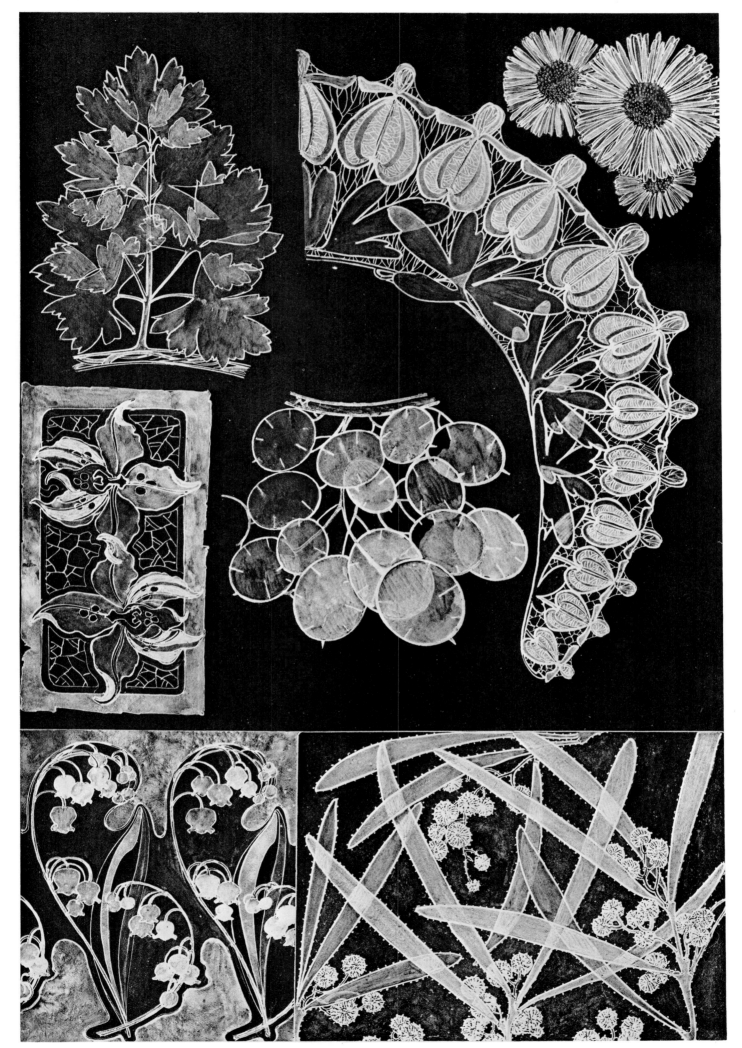

PLATE 39

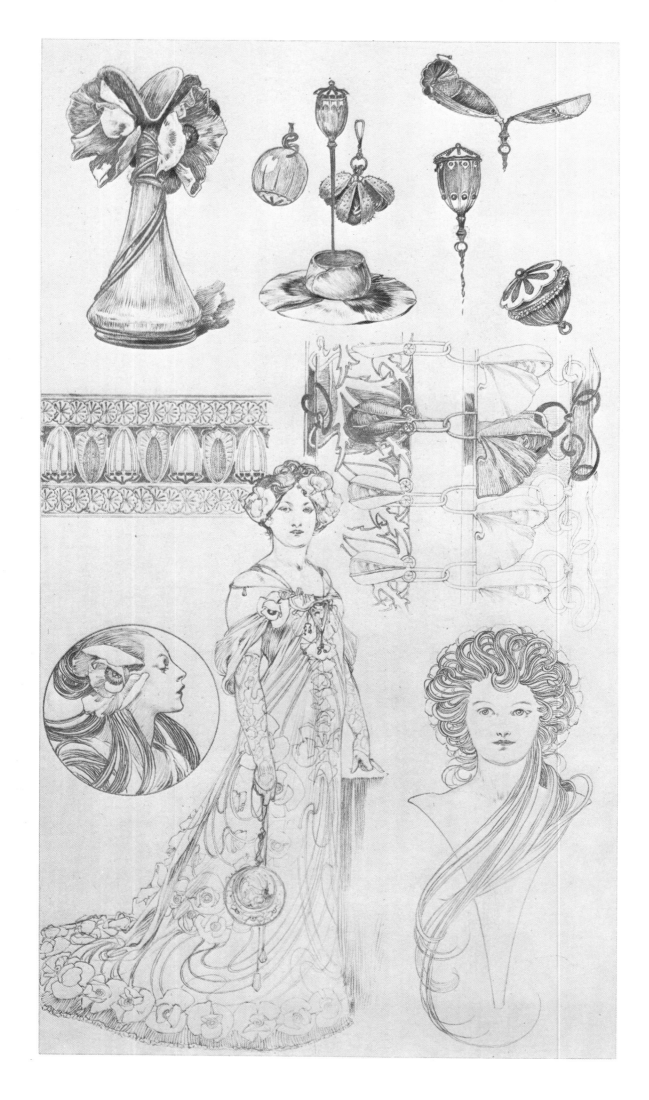

PLATE 40

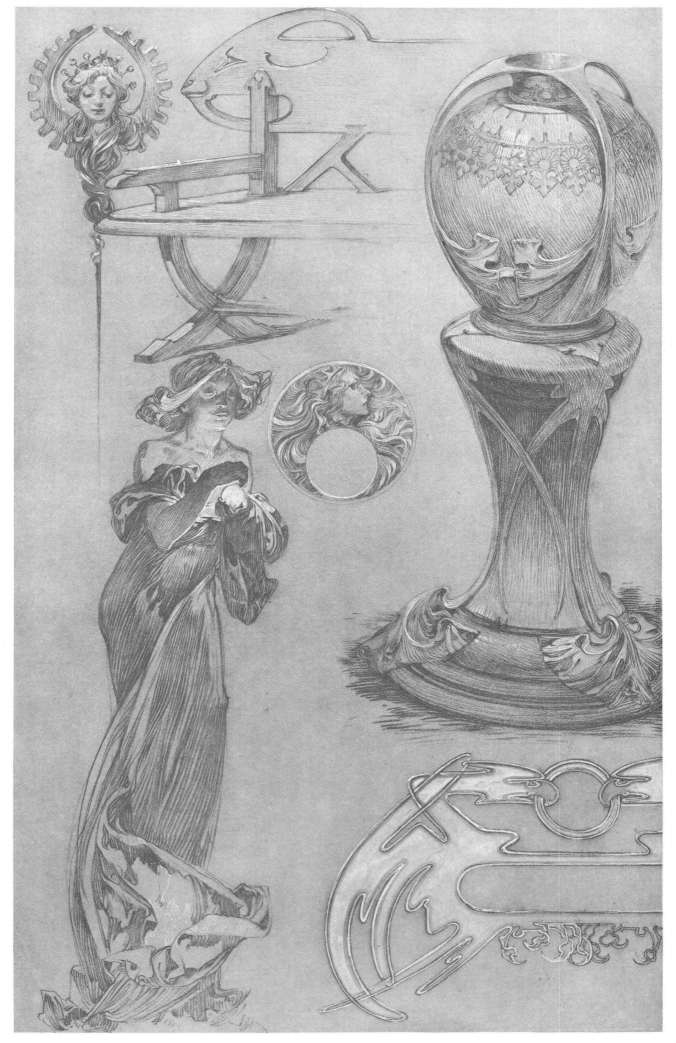

PLATE 41

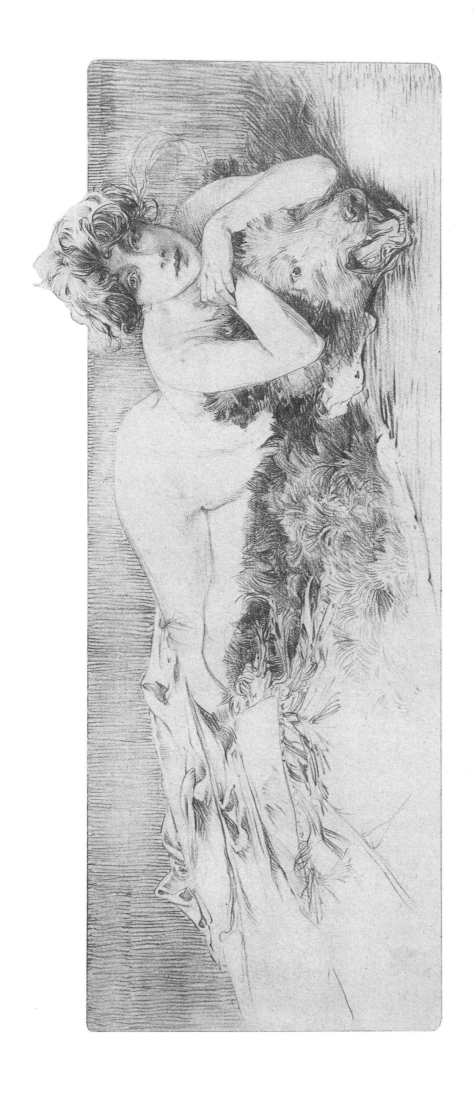

PLATE 42

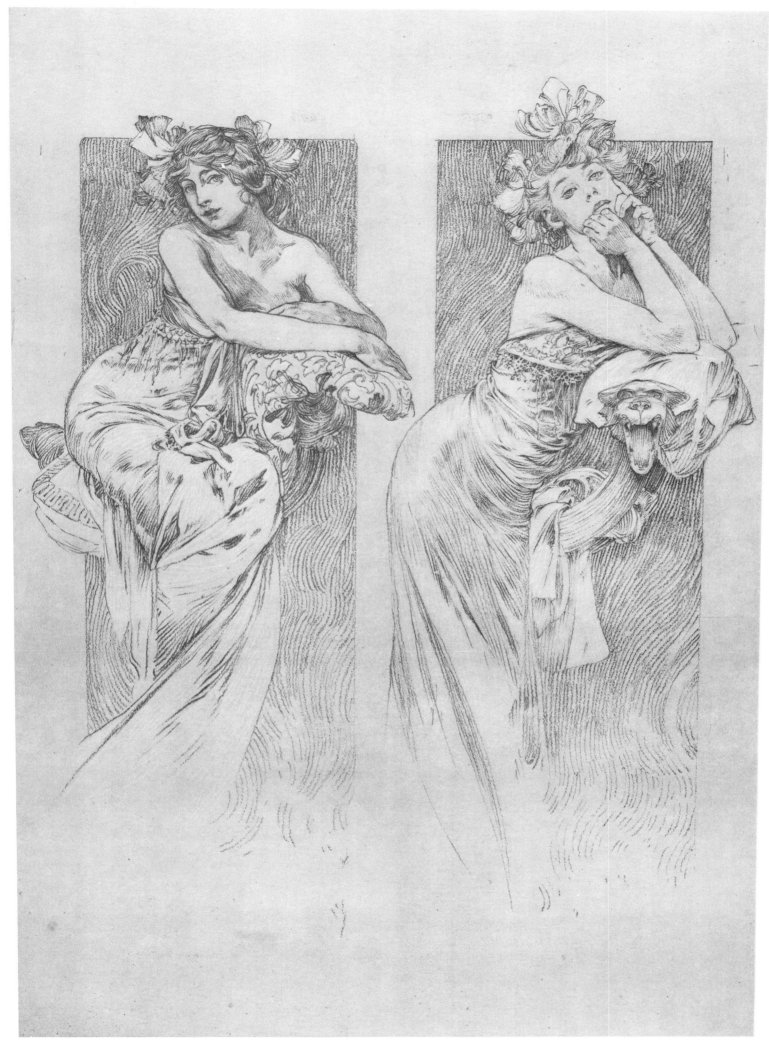

PLATE 43

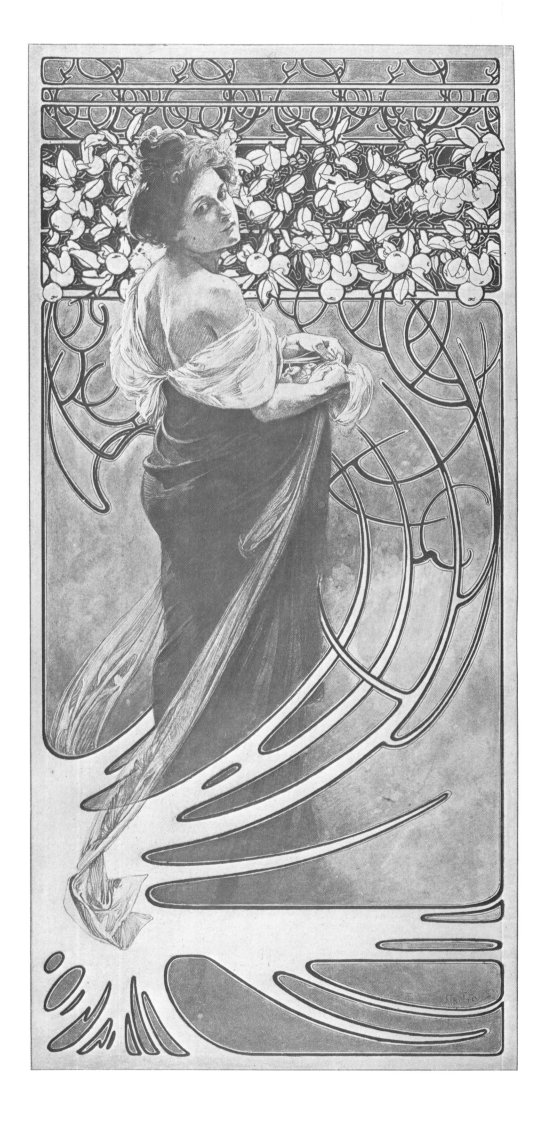

PLATE 44

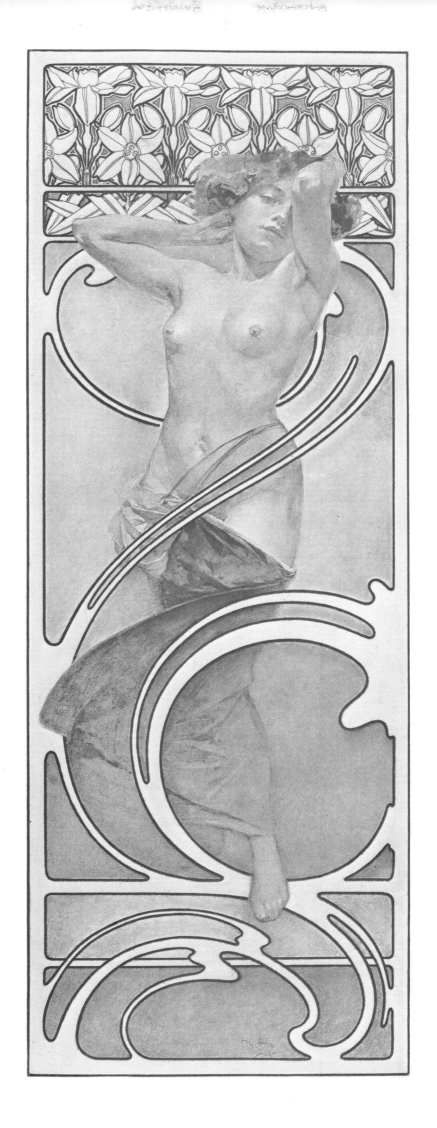

PLATE 45

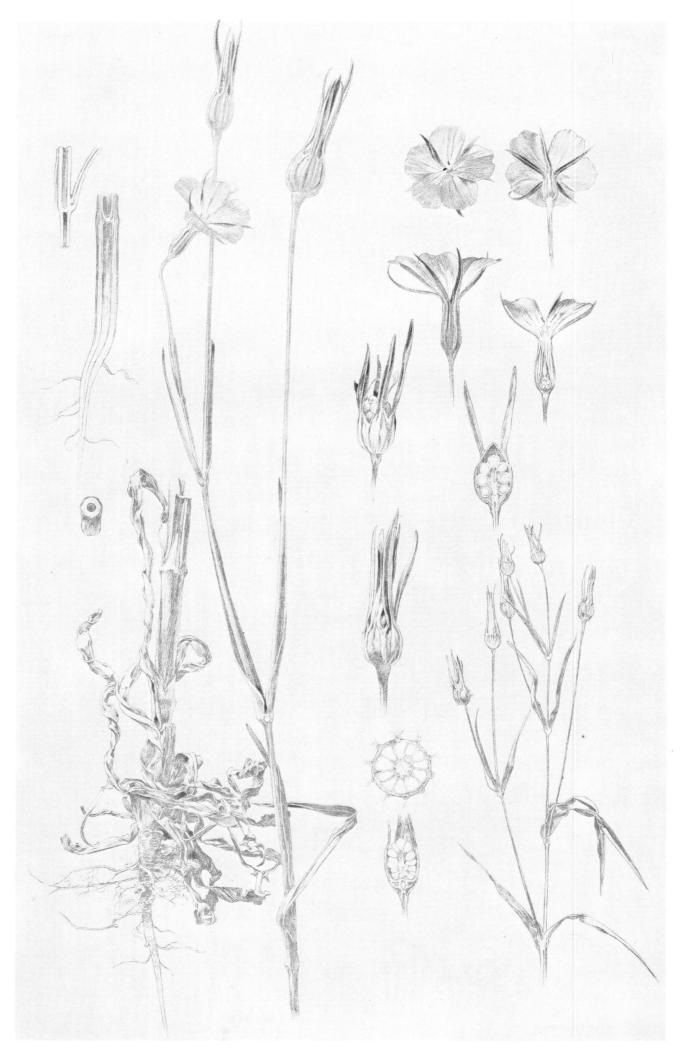

PLATE 46

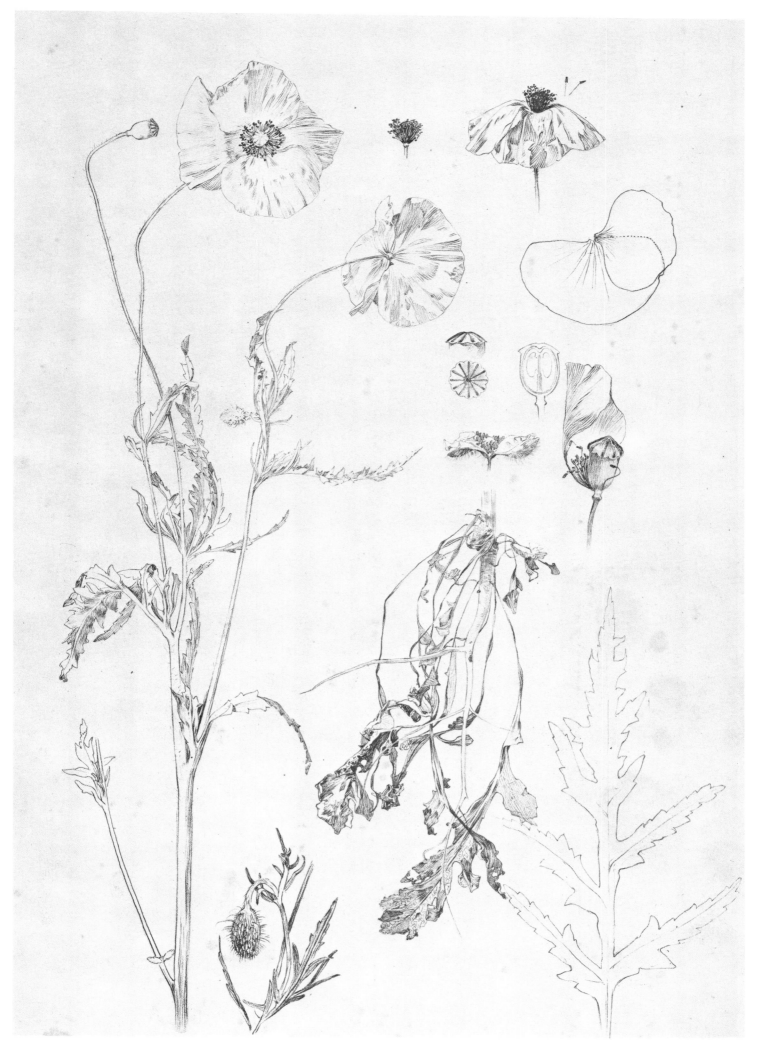

PLATE 47

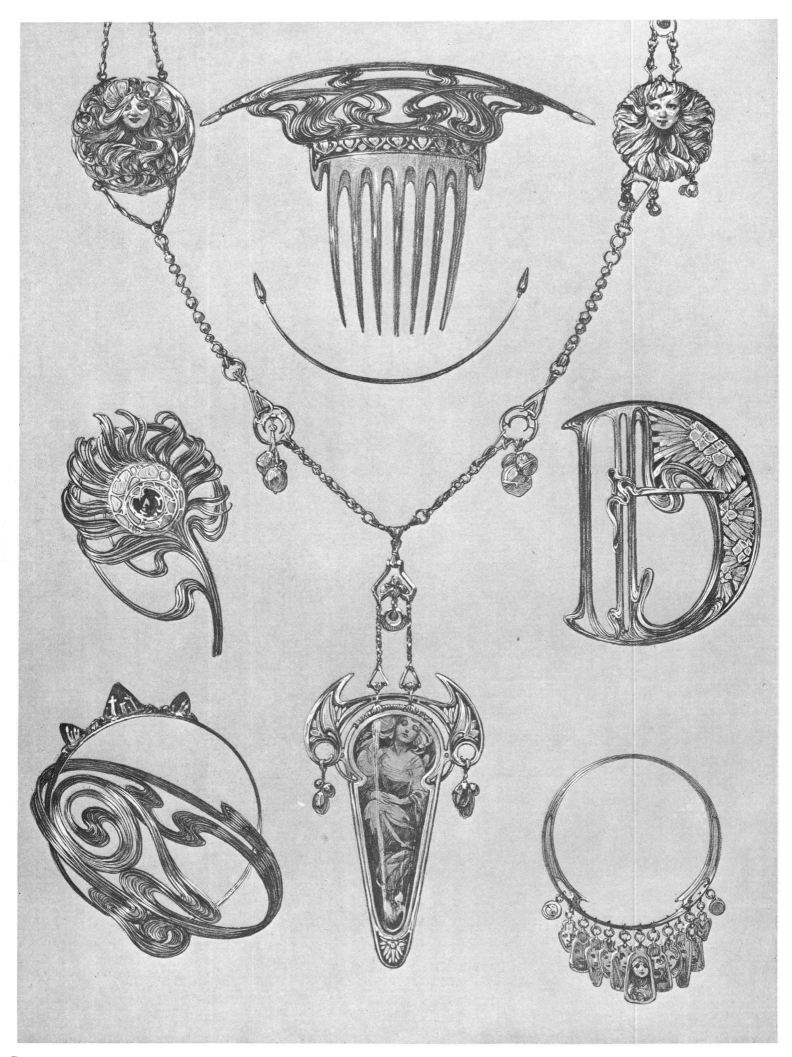

Plate 48

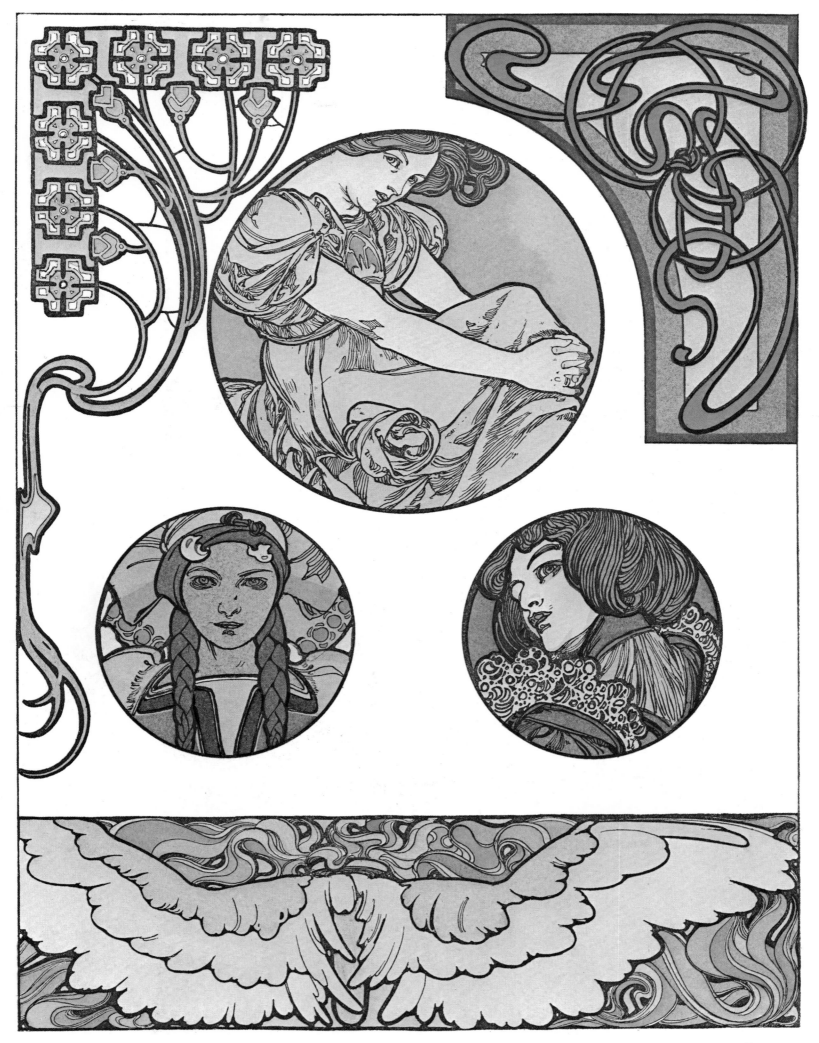

PLATE 49

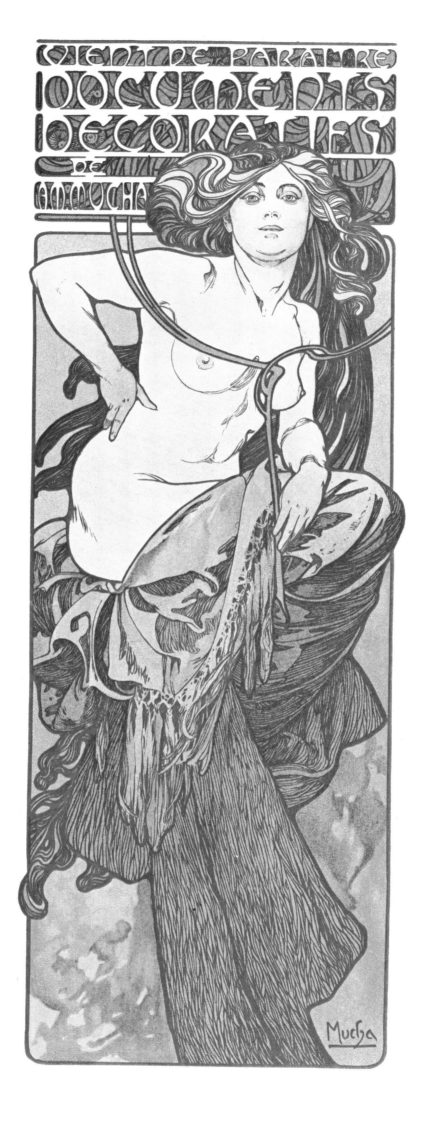

PLATE 50

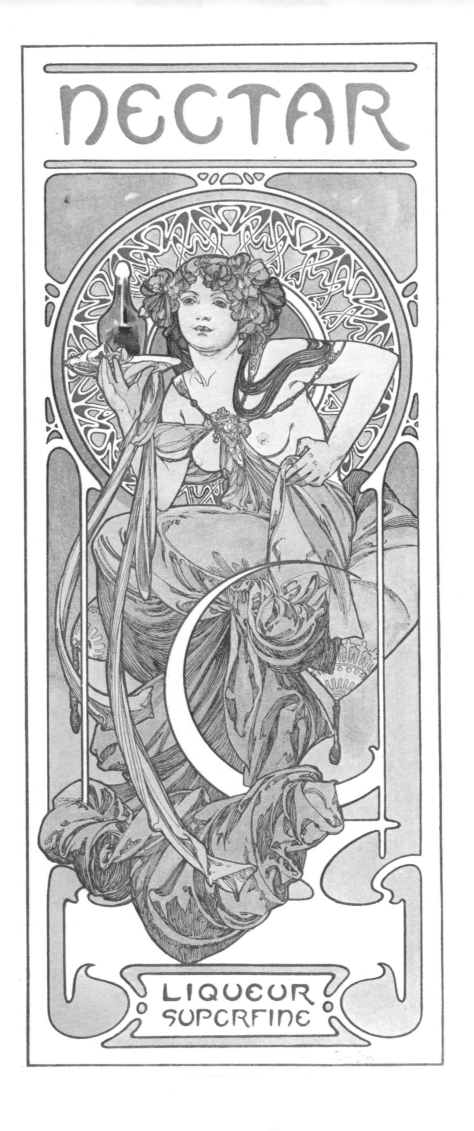

NECTAR

LIQUEUR
SUPERFINE

PLATE 51

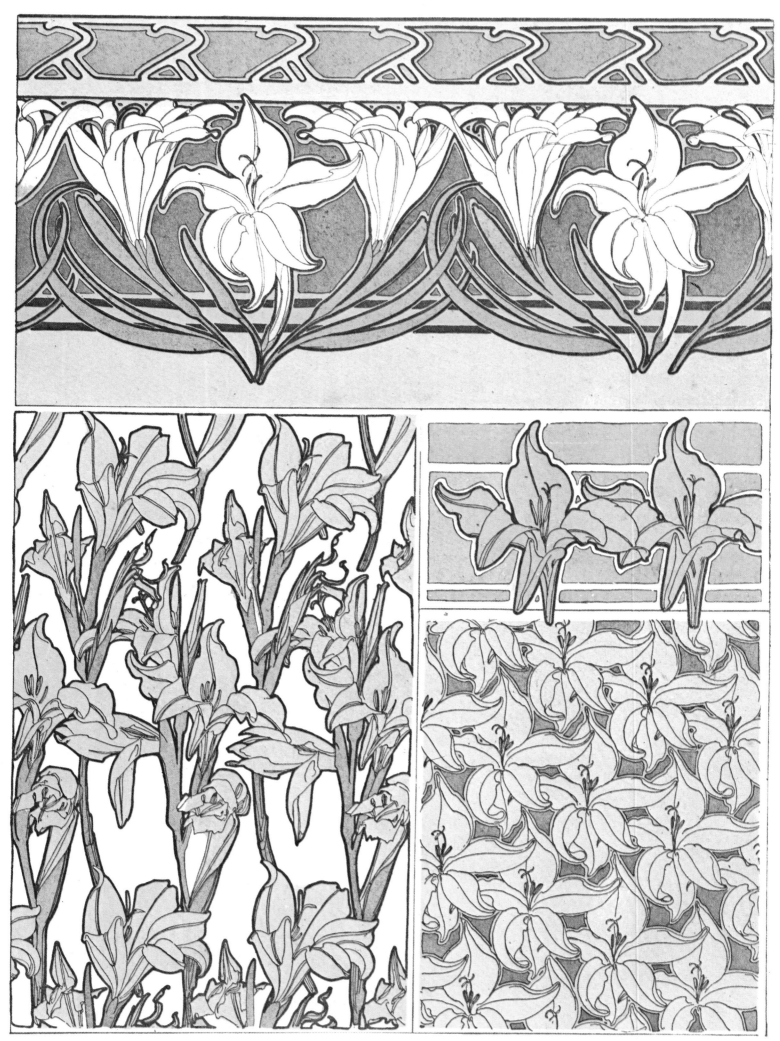

PLATE 52

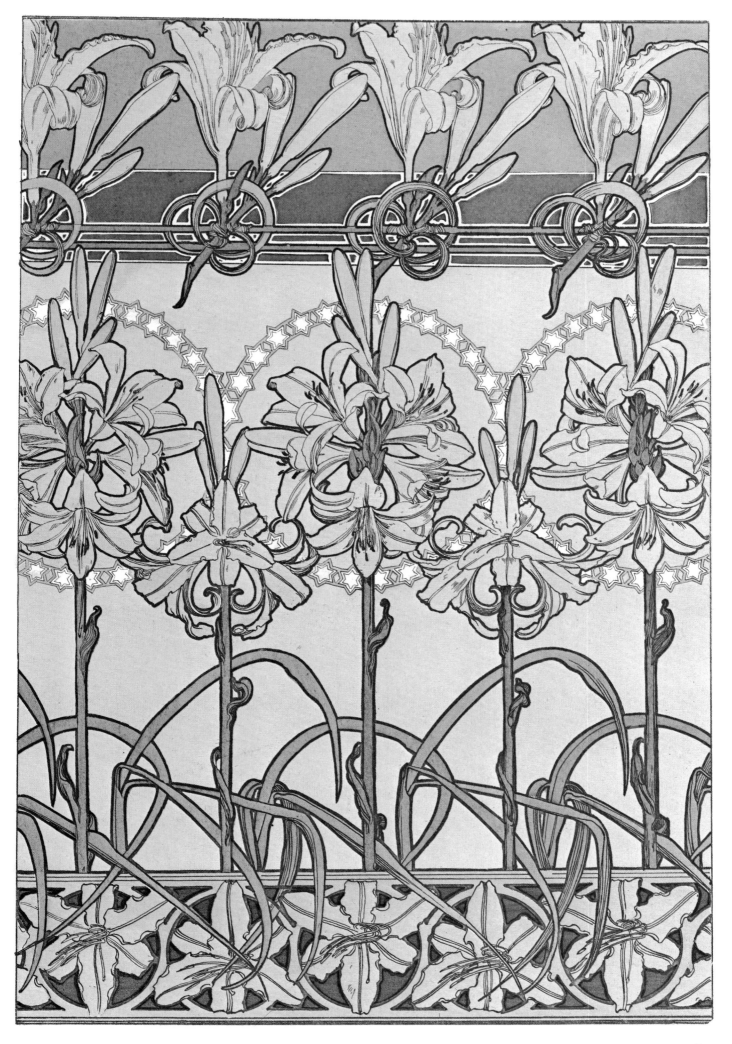

PLATE 53

# AU PARADIS DES BEBES

## ETRENNES!

## AL' ARBRE DE NOEL

Mucha

PLATE 54

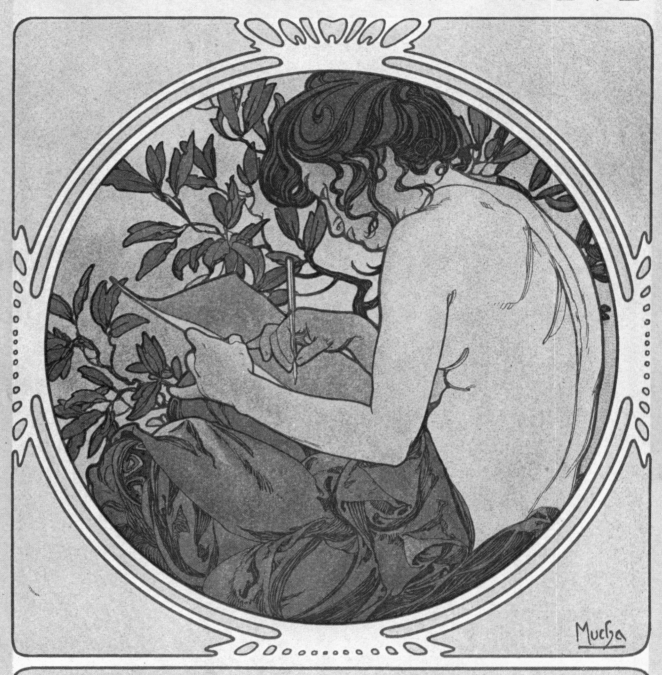

# ART ET DECORATION
## REVUE MENSUELLE D ART MODERNE

Mucha

LIBRAIRIE CENTRALE DES BEAUX-ARTS
13 RUE LAFAYETTE PARIS.

PLATE 55

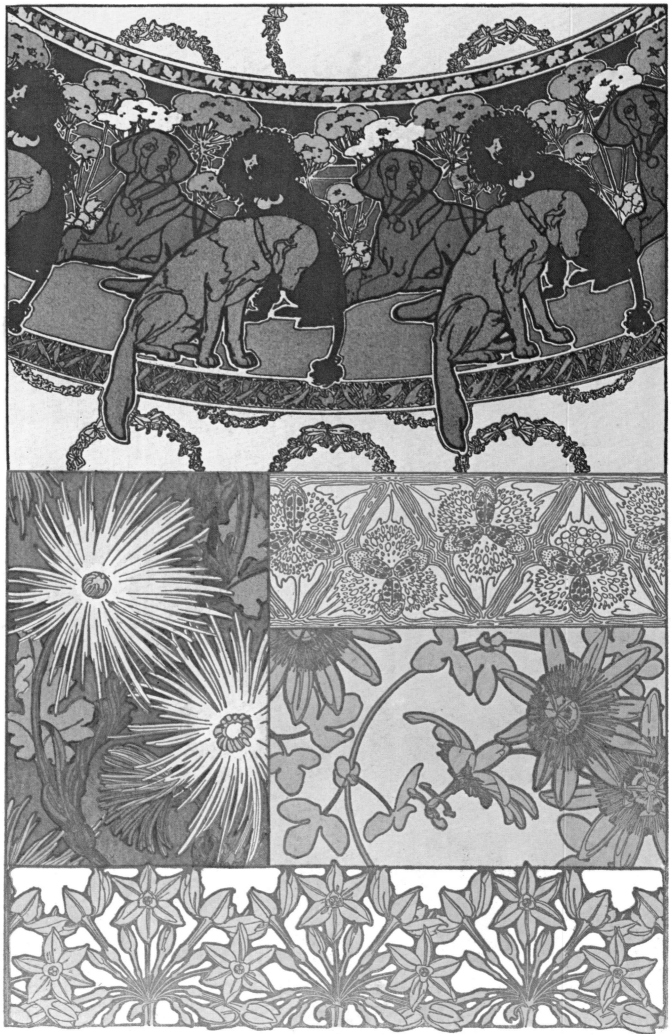

Plate 56

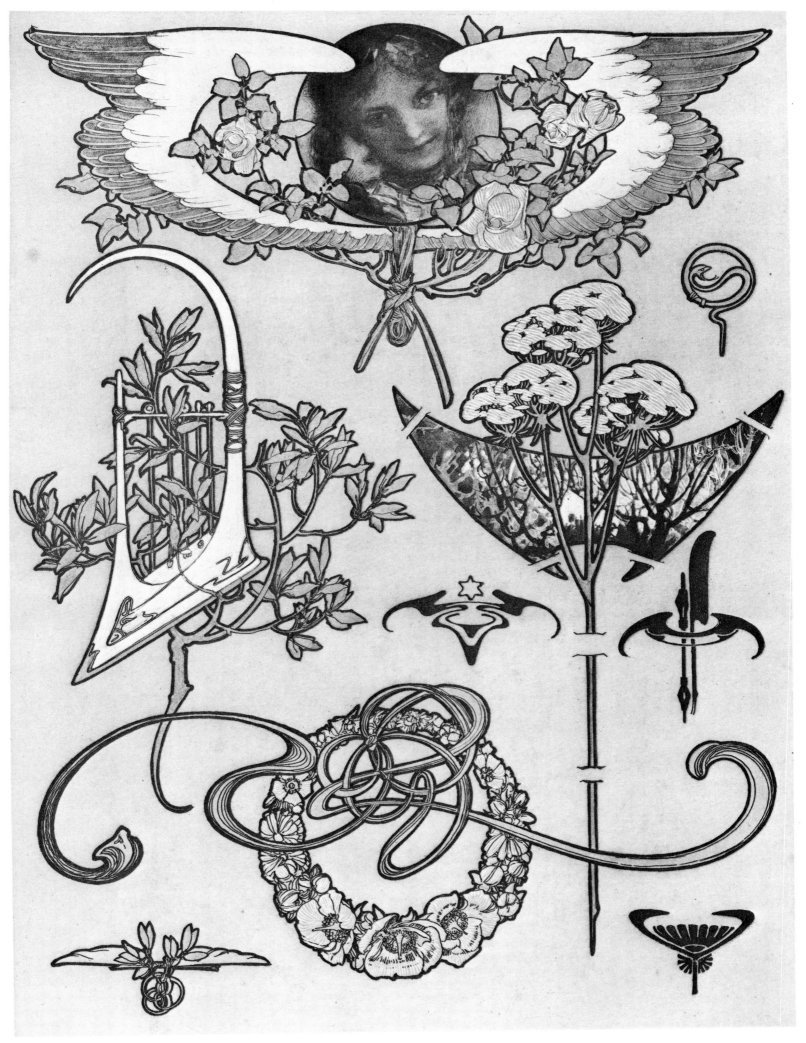

PLATE 57

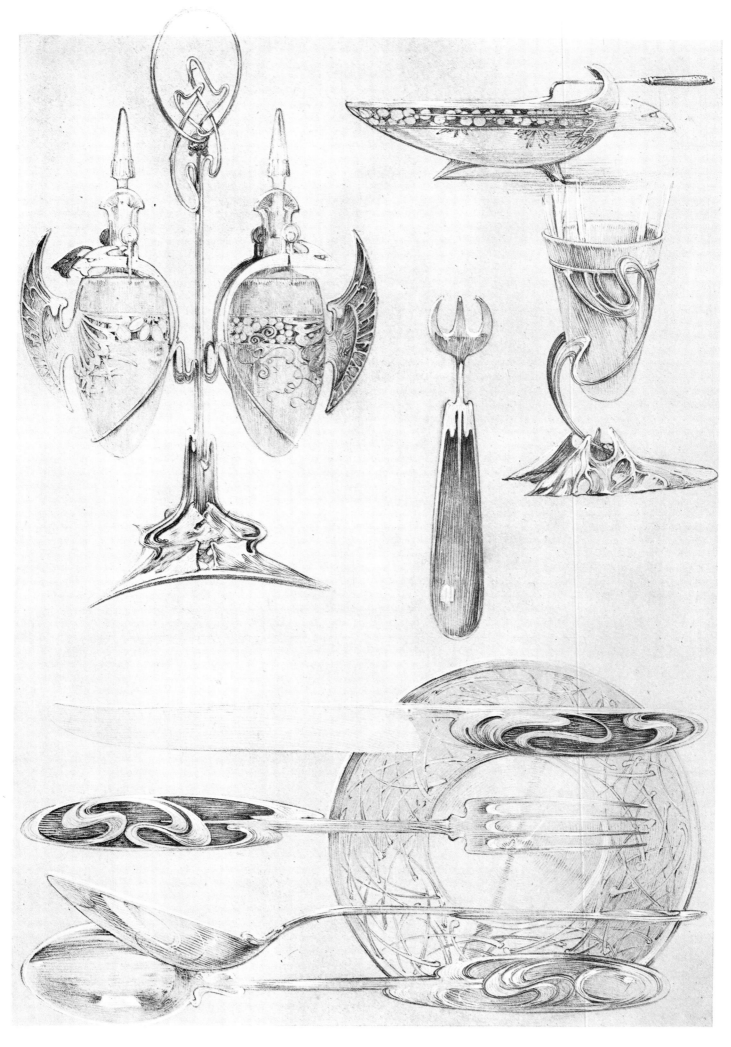

Plate 58

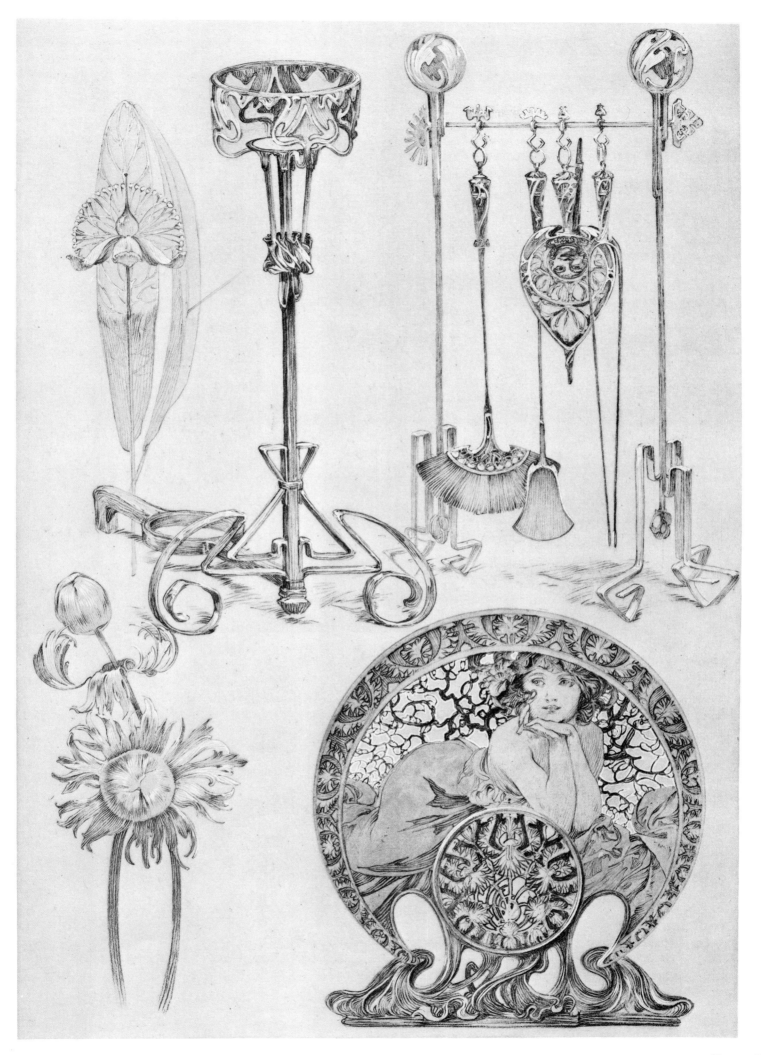

PLATE 59

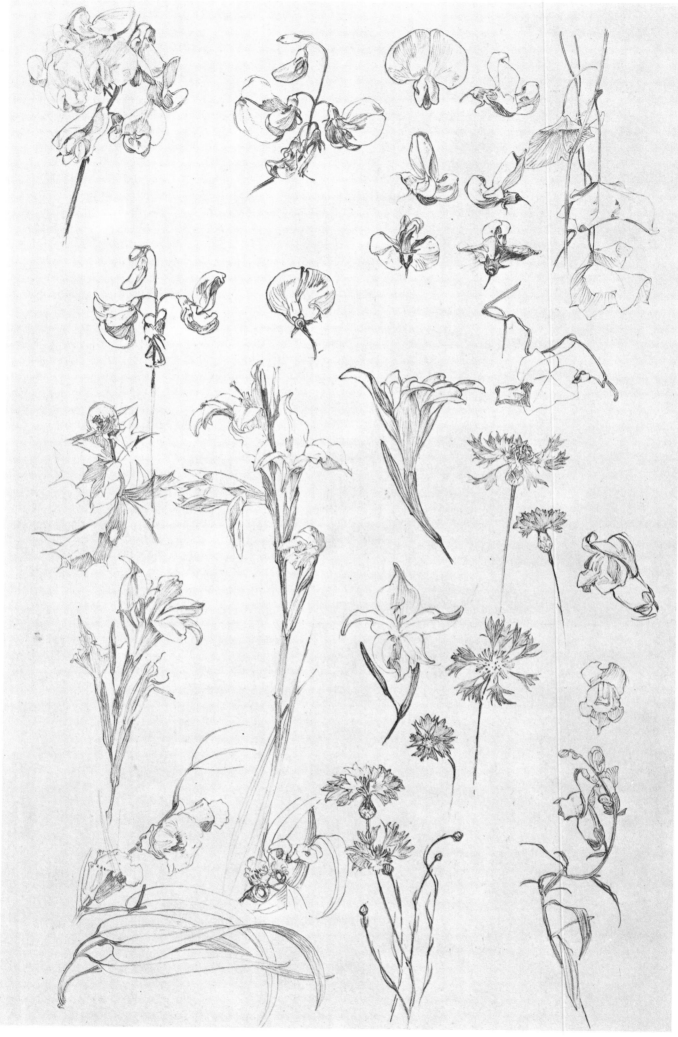

PLATE 60

Croquis de fleurs (Sketches of flowers)

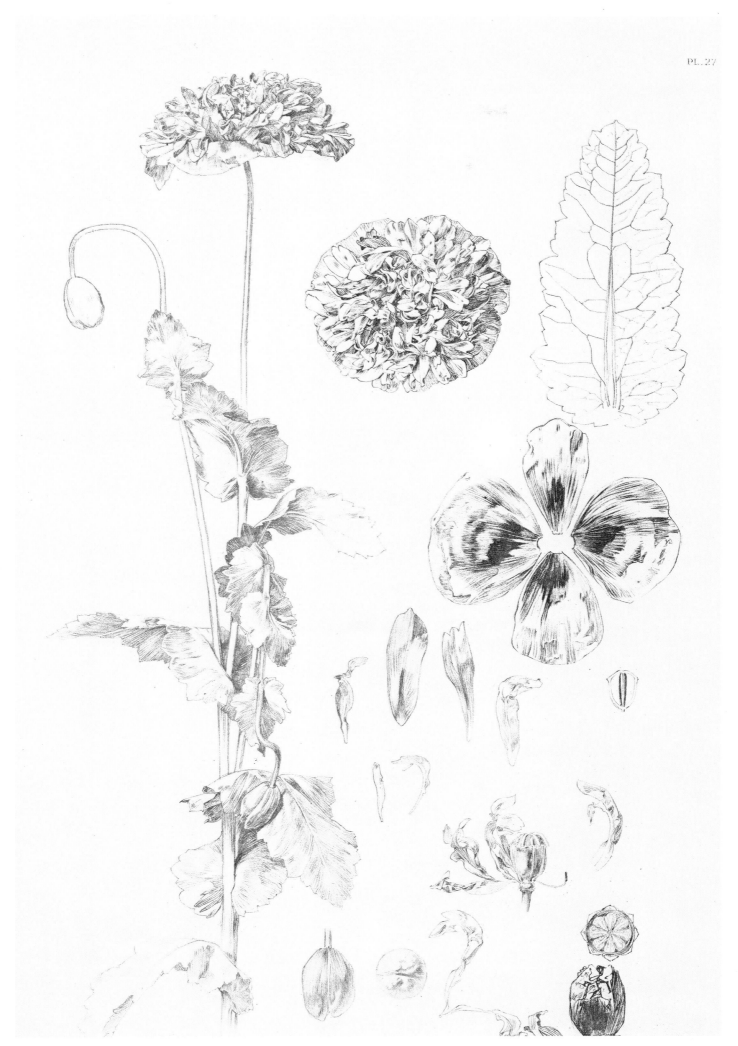

Pavot double (Double poppy)

PLATE 61

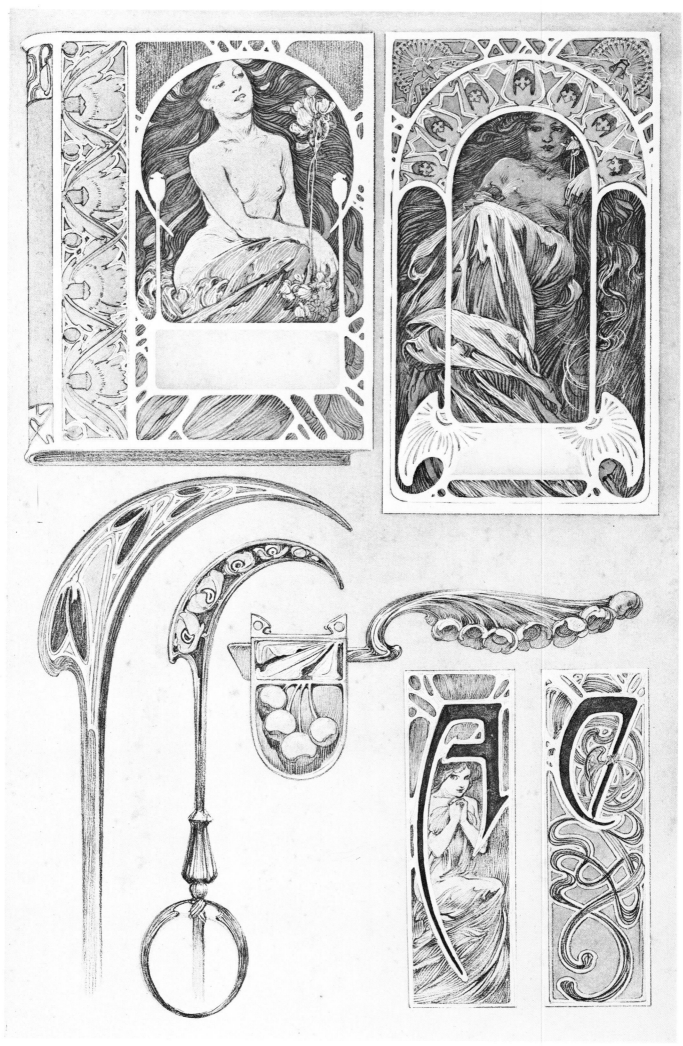

PLATE 62

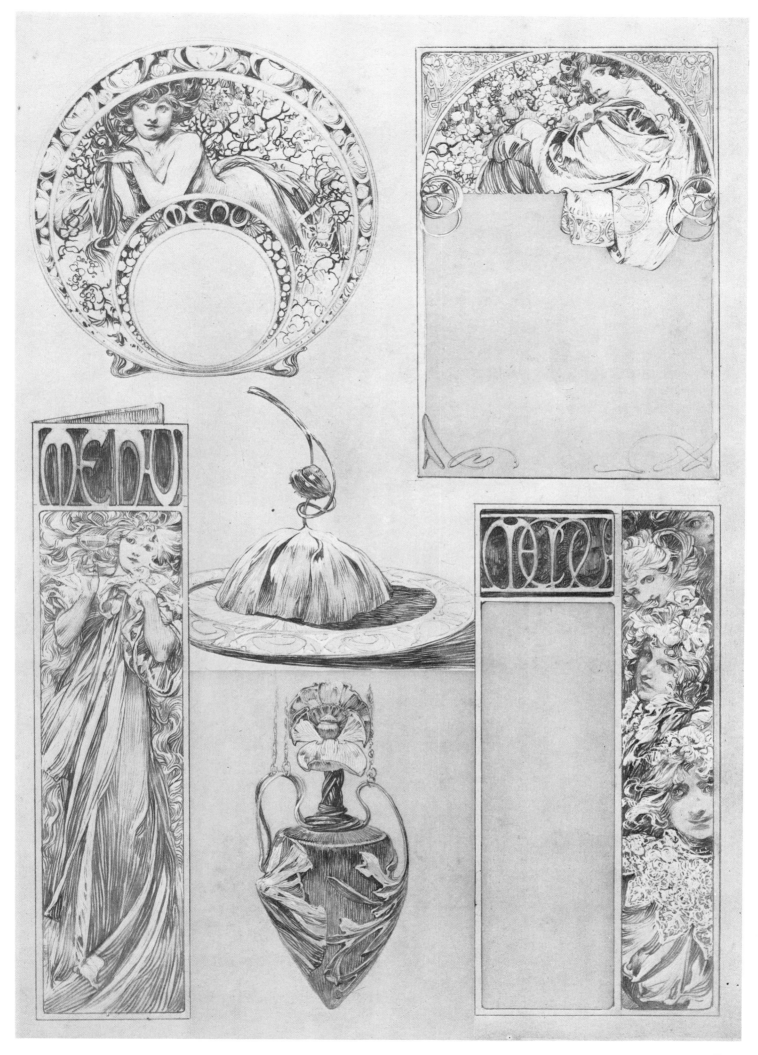

PLATE 63

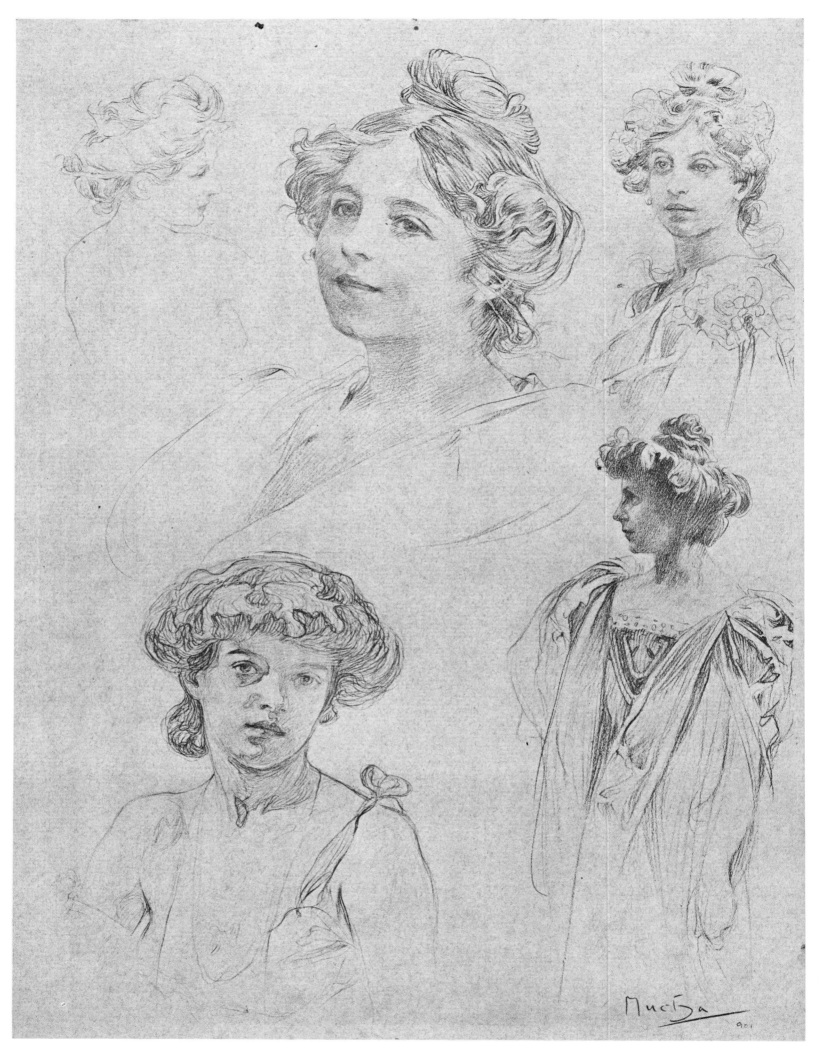

PLATE 64

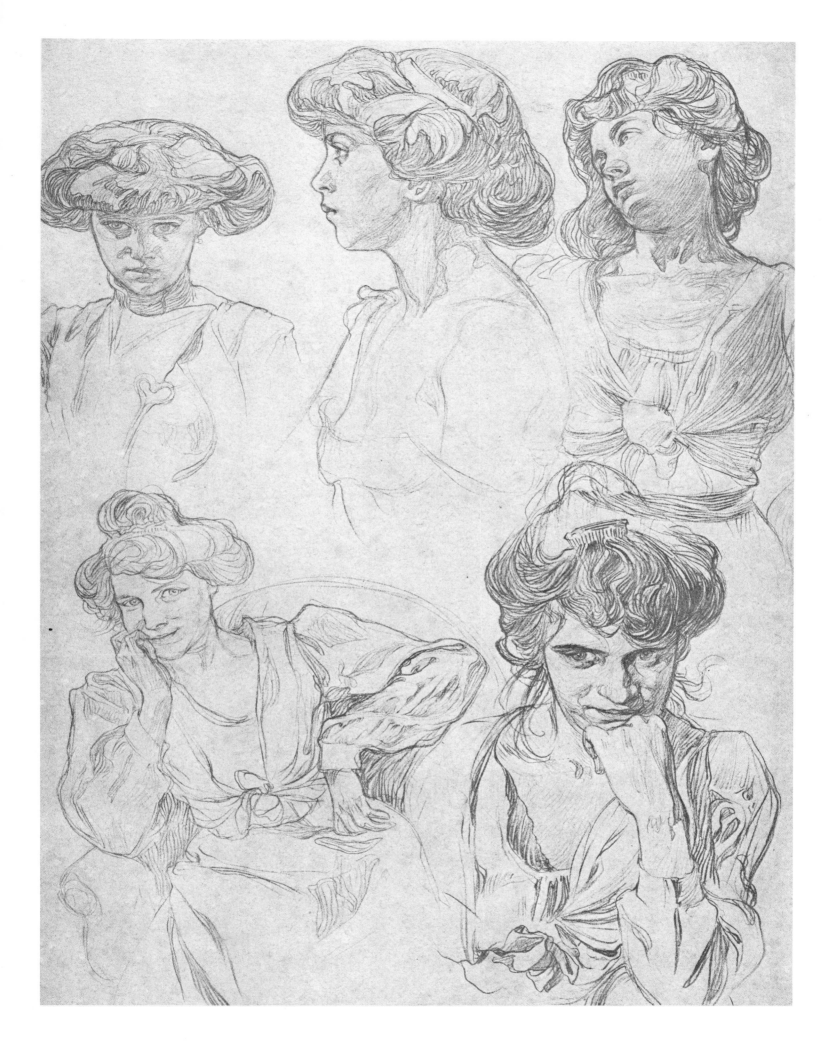

PLATE 65

INTRODUCTION

PREFACE

AVANT=PROPOS

PLATE 66

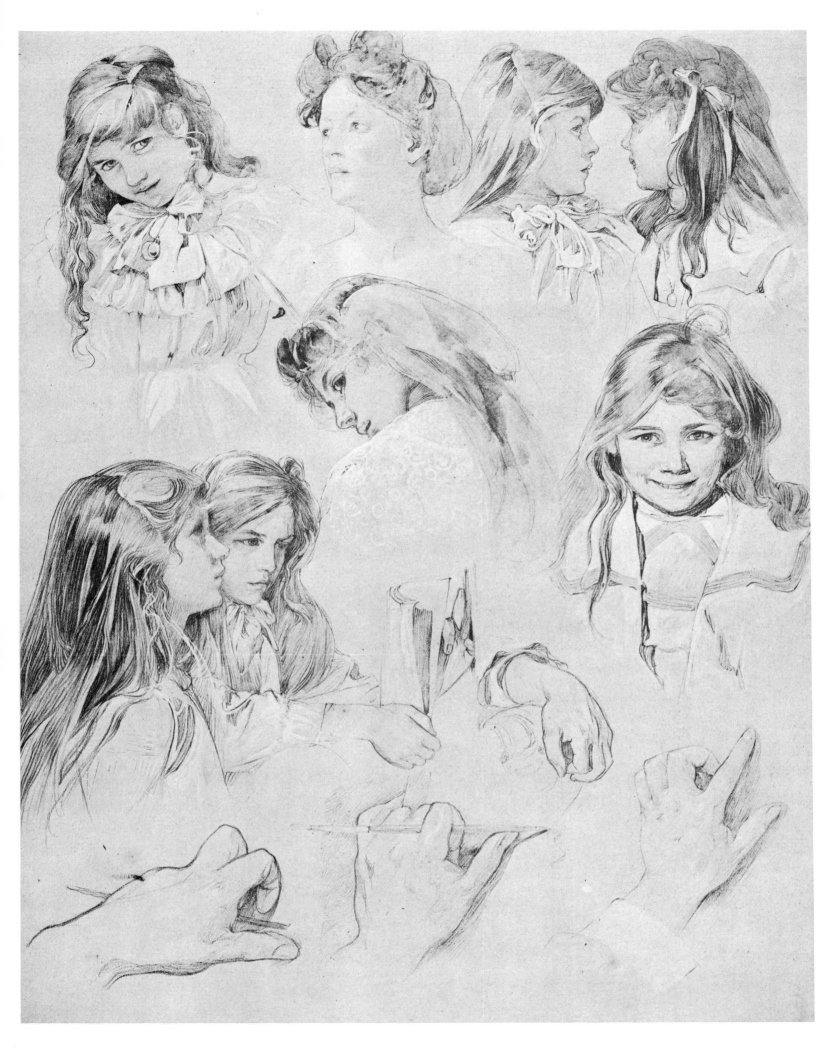

PLATE 67

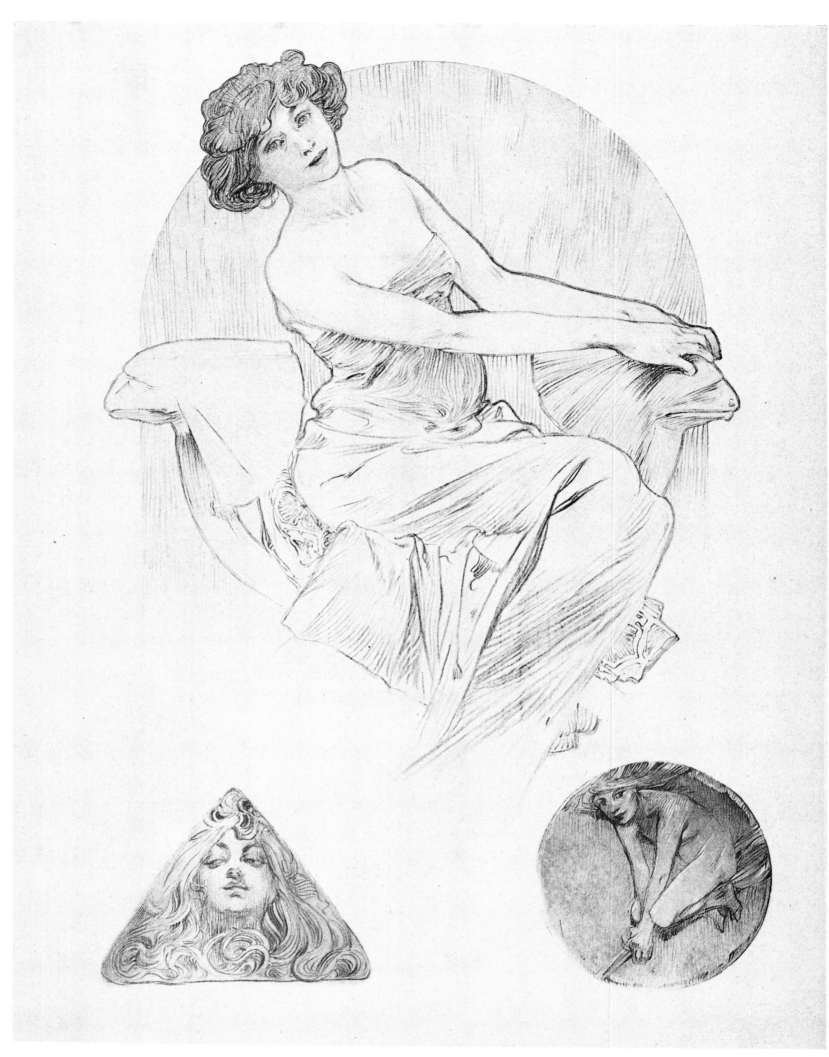

PLATE 68

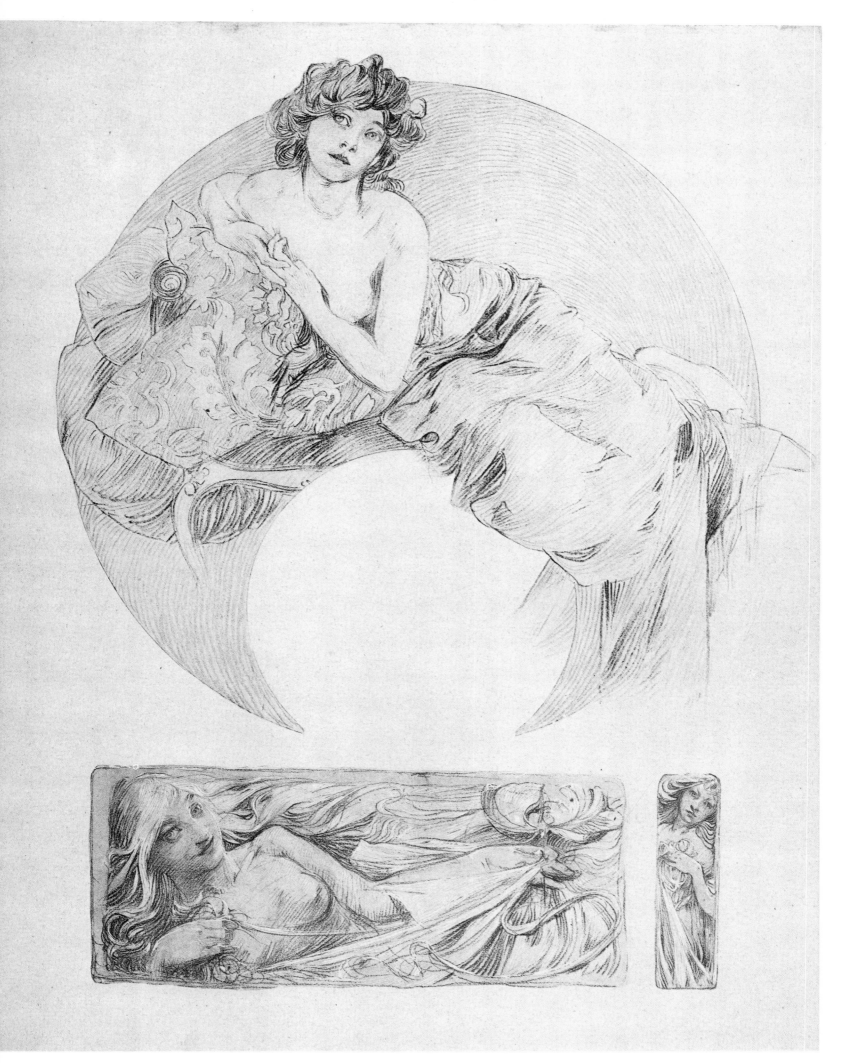

PLATE 69

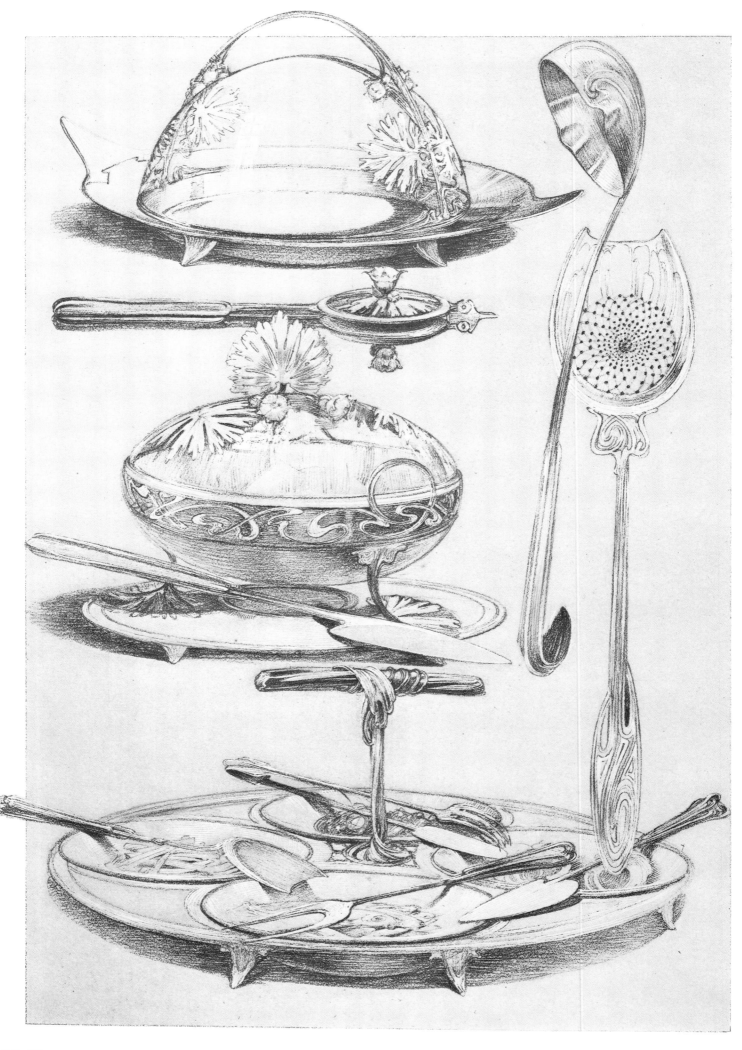

PLATE 70

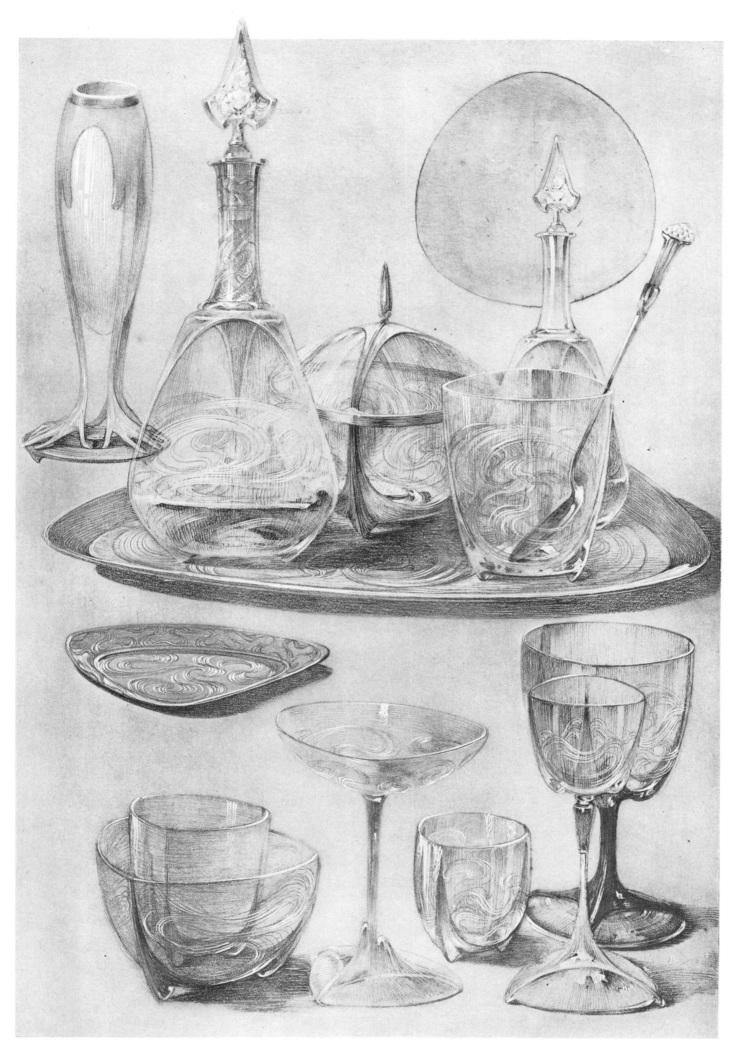

PLATE 71